painting
landscapes
filled with
light

dorothy dent

north light books
cincinnati, ohio
www.artistsnetwork.com

Other fine North Light Books are available from your local bookstore, art supply store or direct from the publisher.

10 09 08 07 06 5 4 3 2 1

Distributed in Canada by Fraser Direct
100 Armstrong Avenue
Georgetown, ON, Canada L7G 5S4
Tel: (905) 877-4411

Distributed in the U.K. and Europe by David & Charles
Brunel House, Newton Abbot, Devon, TQ12 4PU, England
Tel: (+44) 1626 323200, Fax: (+44) 1626 323319
Email: mail@davidandcharles.co.uk

Distributed in Australia by Capricorn Link
P.O. Box 704, S. Windsor NSW, 2756 Australia
Tel: (02) 4577-3555

Library of Congress Cataloging-in-Publication Data

Dent, Dorothy
 Painting landscapes filled with light / Dorothy Dent.
 p. cm.
 Includes index.
 ISBN 1-58180-736-8 (pbk. : alk. paper)
 1. Landscape painting--Technique. 2. Decorative painting. I. Title.
 ND1473.D465 2006
 751.45'36--dc22
 2005014448

Editor: Holly Davis
Production Coordinator: Kristen Heller
Cover Design: Clare Finney
Designer: Terri Schmitt, Eubanks Design
Interior Layout Artist: Kathy Gardner
Photographer: Christine Polomsky

About the Author

Dorothy Dent began teaching decorative painting classes in 1972, soon growing her home studio into the nation-ally known Painter's Cor-ner, Inc. shop and studio in Republic, Missouri. She began self-publishing painting instruction books in 1980 and has published twenty-nine titles since then. Her painting series, *The Joy of Country Painting*, appeared on PBS, and Bob Ross published two companion books. Her work has appeared in all the decorative painting magazines, including *Decorative Artist's Workbook*. Besides *Painting Landscapes Filled with Light*, Dorothy has also published *Painting Four Seasons of Fabulous Flowers* and *Painting Realistic Landscapes with Dorothy Dent* for North Light Books. Dorothy continues to teach not only in her shop but all over the United States, Canada, Japan, Argentina and Australia. She is now offering a Dorothy Dent Certification program for those who want to further their painting skills in her tech-niques. Her schedule and art can be seen on her Web site, www.ddent.com.

Metric Conversion Chart

to convert	to	multiply by
Inches	Centimeters	2.54
Centimeters	Inches	0.4
Feet	Centimeters	30.5
Centimeters	Feet	0.03
Yards	Meters	0.9
Meters	Yards	1.1

Dedication

I would like to dedicate this book to those of you who have bought so many of my books and taken so many classes from me over the years. Without this support, I would not have been able to do this book, nor would I have been able to make a living from this work I enjoy so much. I have been in the decorative painting industry for over thirty years, and the time has flown. I have come in contact with so many nice people and have made many good friends. I dedicate this book to all of you who have shown so much interest in my art and enabled me to continue.

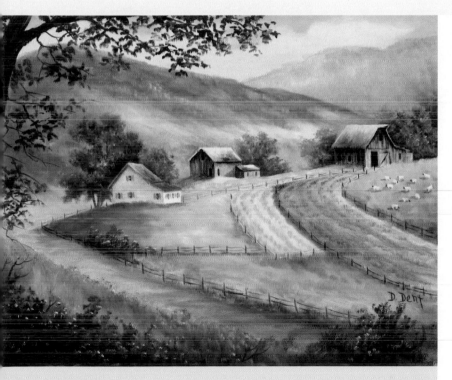

Acknowledgments

Thank you to the editors at North Light for your encouragement and help in putting this book together. I think North Light Books publishes some of the most beautiful books on the market, and I feel honored to work with this company. I am espe cially appreciative to Kathy Kipp and Holly Davis, the two editors I work with most closely, and to Christine Polomsky, who did all the photography as I painted. You are all wonderful to work with.

A special thanks to my staff at Painter's Corner, who have been with me so many years and who help me immensely. I also would like to thank my husband, D. A. Garner, who is ever supportive of what I do.

contents

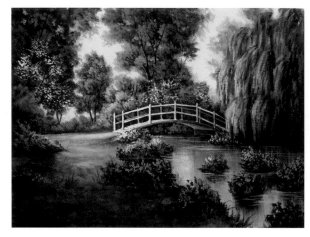

acrylic

oil

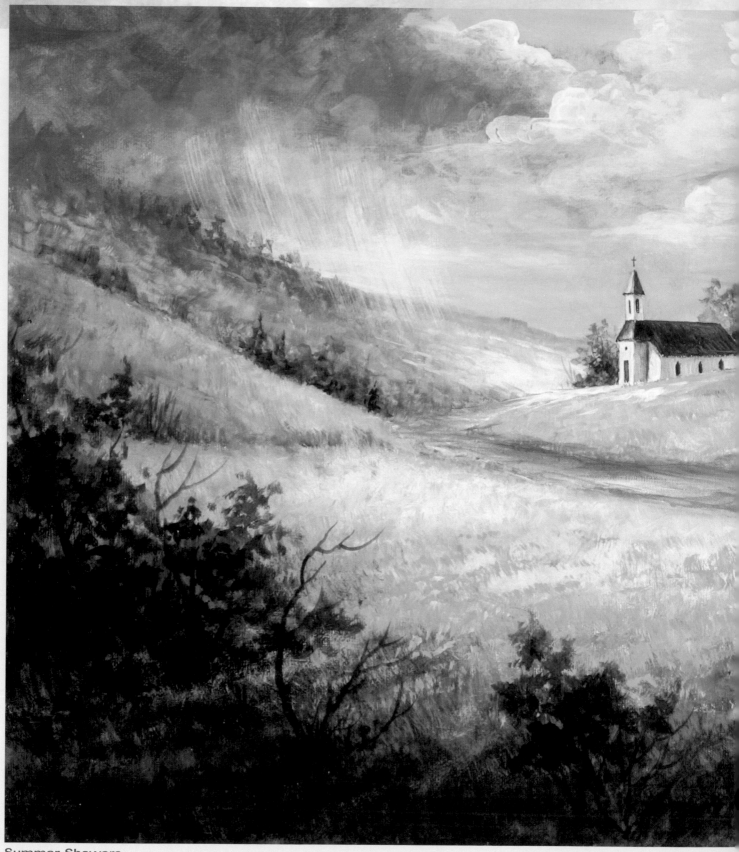

Summer Showers

introduction

I love to work with light in my paintings. In fact, working with light is what painting is about. Painters should always be aware of how light illuminates their subject. Then the task is to represent that light in their work. Light is what draws your attention and interest to a painting.

However, without dark, there is no light. The contrast between light and dark values makes a painting work. Dark values show the shapes of objects and really make the lights shine. As you work through the projects in this book, you'll learn different ways of using dark values against light values to get the best possible effects.

The importance of light against dark holds true in all painting mediums, so when editor Kathy Kipp first spoke to me about doing a book with both acrylic and oil projects, I thought the idea was great. I'm basically an oil painter, and most of my self-published books are for oil painters, but several years ago I realized that the majority of decorative painters are working in acrylic, so I started offering instruction in that medium. Hopefully, this book has something for everyone. Besides addressing both acrylic and oil, I've included the full range of seasons. Some projects are easier than others, but with the color step-by-step photos and clear instructions, I don't think anyone will have difficulty painting any of the scenes.

If you're an acrylic painter, of course you can paint the oil pieces in acrylic simply by matching the general colors and using acrylic painting techniques. Conversely, oil painters can paint the acrylic projects in oil. On the other hand, if you are an acrylic painter who is yearning to try oil but has been afraid to try, this book provides a great opportunity to experiment. If you paint in oil and want to try acrylic, here's your chance to jump right in. Differences between the two techniques are discussed under "Acrylic or Oil?" on page 14.

Both mediums are fun, and trying something new is a great learning experience. Who knows—you might fall in love with that untried medium. This book gives you help and, hopefully, "the light" to try something new.

surfaces and preparation

Whether you work in acrylic or oil, before making that first brushstroke, you need to gather a few general supplies and prepare your painting surface. The information on these two pages will get you off to a good start.

Surfaces and Preparation Supplies

1. Stretched canvas - All ten paintings in this book are painted on stretched canvas, either 11" x 14" (28cm x 36cm) or 12" x 16" (31cm x 41cm). You can find these ready-made in craft or painting supply stores. Choose a smooth-surfaced canvas. Portrait grade is best.

 Of course, you can paint landscapes on any surface as long as you prepare it correctly and make any necessary painting adjustments. Ask someone at your local craft or hobby store for advice.

2. Gesso - Stretched canvas comes with a gesso coating, but I apply additional coats for a smoother surface. This is especially necessary when working with acrylics. It's also nice for oils, but if you have a smooth, tightly woven canvas, it may not be necessary.

3. 2-inch (51mm) disposable sponge brush - Use this to apply the gesso.

<div style="writing-mode: vertical">materials</div>

Applying Gesso

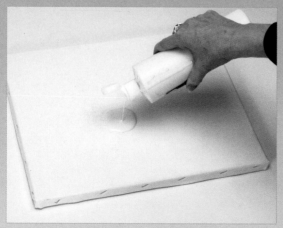

1 Pour It On

Pour a puddle of gesso on the canvas.

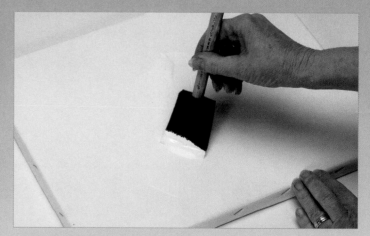

2 Spread It Out

Spread the gesso evenly on the canvas with a 2-inch (51mm) sponge brush. Clean the brush with soap and water.

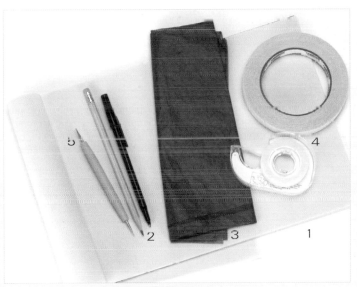

Supplies for Pattern Transfer

To transfer patterns onto your painting surface, you need these:

1. Tracing paper - This is a translucent paper onto which you trace patterns from the book.

2. Pencil or pen - Use one of these to trace your pattern.

3. Black graphite paper - This is a thin paper with a removable coating on one side that's used to transfer the traced pattern onto the painting surface.

4. Scotch tape or masking tape - Use one of these for holding the traced pattern in place while you're transferring it onto the painting surface.

5. Stylus - This tool works well for transferring the pattern. You may use a pen or pencil instead.

A Few More General Supplies

1. Table easel - An easel props up your canvas as you're painting. A table easel allows you to sit while you work.

2. Palette paper - With both acrylics and oils, I prefer working with disposable palette paper. There are many types and brands available. Check the labels carefully and select palette paper that is appropriate for your paint (acrylic or oil).

3. Paper towels - You'll use paper towels for a variety of painting tasks. The more absorbent are best.

4. Wipe out tool - This is handy for lifting off oil paint to make corrections or for scratching out some wet sky where you want to put a tree.

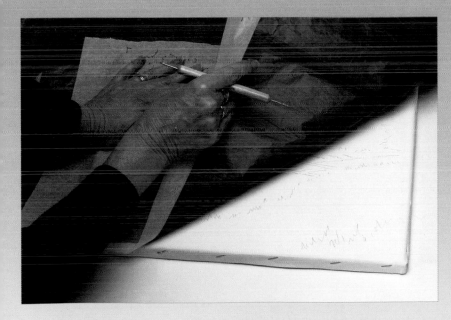

Transferring the Pattern

Once you've traced your pattern position it on a gesso-covered canvas, being sure the canvas is dry. Secure the pattern to the canvas at the top only with masking tape or Scotch tape. With the dark side down, slip the graphite paper between the traced pattern and the canvas. Trace over the pattern lines with a stylus, pen or pencil. As you press down, the coating on the graphite paper will adhere to the canvas, creating a light reproduction of the pattern lines.

acrylic materials

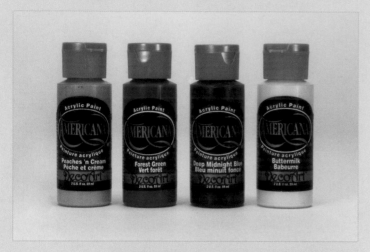

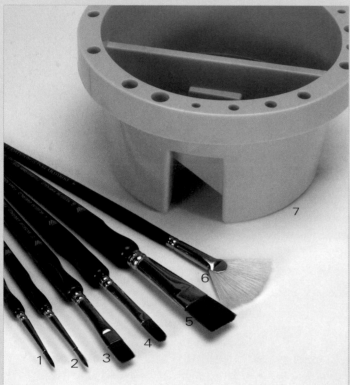

DecoArt Americana Acrylic Paint

The acrylic paint I used in this book is DecoArt Americana Acrylic. This paint is widely available in hobby and craft shops.

Acrylic Brushes and Brush Basin

When painting the acrylic projects for this book, I generally used synthetic brushes—specifically, Martin/F. Weber Museum Emeralds. To aid your painting and care for your brushes, you'll also need a brush basin.

1. Pointed round
2. Liner
3. Flat
4. Filbert
5. Flat wash/glaze
6. Bristle fan - This is the one nonsynthetic brush I use with acrylics. To prevent bristle distortion, avoid letting the brush soak in water. I prefer the Dorothy Dent foliage fan.
7. Brush basin - Any container that holds water will do, but with a divided brush basin you can use the water in one side to rinse and the water in the other side for mixing paint and adjusting consistency. Many brush basins have other helpful features, such as paint-cleaning ridges and brush holders.

TIP

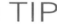

Having trouble finding a particular material?
See "Resources" on page 142.

Caring for Acrylic Brushes

Because acrylic dries so quickly, it's important to remember to rinse your brushes during your painting session and to clean them thoroughly after your painting session. Avoid laying down a brush full of paint while you work with another brush or go to answer the phone. The paint may dry in the brush and ruin the bristles. Instead, make it a habit to swish out the brush in rinse water before setting it aside.

At the end of the painting session, clean your brushes thoroughly with soap and water. Most brushes used with acrylic are synthetic, so the water won't soak into the bristles or cause them to lose their shape.

Store your brushes in a container that will keep them separated and secure.

materials

Setting Up an Acrylic Palette

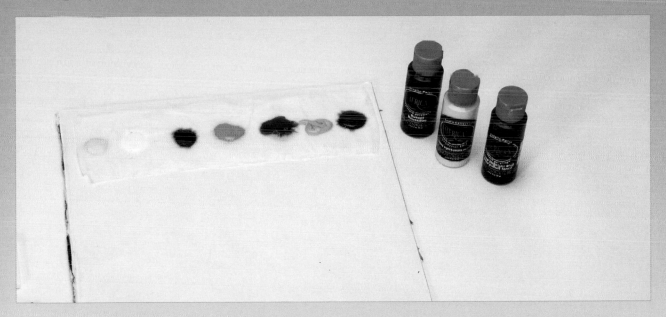

Although I use disposable palette paper for both acrylic and oil (see page 9, "A Few More General Supplies"), the palette set-up for the two differs.

To set up an acrylic palette, dampen a paper towel with water. Then fold it and lay it on one side of the palette. Squeeze your paint colors onto the wet paper towel. This keeps the paint wet for hours. Use the rest of the palette for brush mixing. Avoid laying your colors so close together that it's difficult to pick up one color without getting into neighboring colors.

DecoArt Americana Varnish

You'll find many varnishes appropriate for acrylics on the market. I prefer DecoArt Americana Sealer Finisher. You can choose from a matte, satin or gloss finish. I use one or two coats of satin or gloss for just the right amount of shine to suit my taste.

Varnish may be either sprayed or brushed on—just be sure your painting is dry. I find brush varnish easier to apply evenly. Use a soft hair flat brush rather than a sponge brush.

oil materials

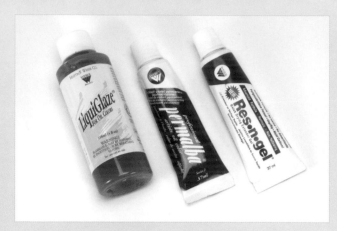

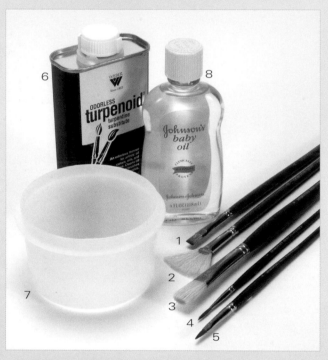

Oil Paints and Mediums

1. Martin/F. Weber Professional Permalba Artists Oil Color - I painted all the oil landscapes in this book with this paint, which is widely available in hobby, craft and art supply stores.

2. Martin/F. Weber Liquiglaze - Adding a bit of Liquiglaze to your colors helps them spread easily.

3. Martin/F. Weber Res-n-gel - I like to add a little Res-n-gel to my white paint to make it dry faster. White is the slowest drying of all oil paints, and it is also mixed with many other colors. Adding a dryer to this one color keeps you from getting bogged down in a lot of wet paint. This is especially helpful when you're painting trees and foliage on top of sky.

Brushes and Related Materials

To paint the oil projects for this book, I used my own Dorothy Dent Brushes. Make sure you have cleaning materials on hand.

1. Detail flat - This brush is equivalent to a no. 8 sable flat.

2. Foliage fan - This brush is equivalent to a no. 4 bristle fan.

3. Small background - This brush is equivalent to a no. 6 bristle flat.

4. Liner - This brush is equivalent to a no. 1 sable liner.

5. Filbert - This brush is equivalent to a no. 4 filbert sable.

6. Odorless turpentine - Use this to rinse and clean your brushes.

7. Basin for odorless turpentine - Any plastic container will do.

8. Baby oil - Work baby oil into the bristles after you wash the brush in oderless turpentine. This strips out any remaining paint.

Caring for Oil Brushes

All brushes should be thoroughly cleaned after each painting session. Clean your oil brushes in odorless turpentine and then work baby oil into the bristles. Wipe out the baby oil until no trace of paint is left.

If you feel you must wash your oil brushes in soap and water, choose a product designed for this purpose. Don't use dish detergents or other soaps with softening agents.

After washing your brushes, be sure to pull them back to their original shapes. Allow them to dry thoroughly before painting with them again.

You cannot paint in oil with a brush that is damp with water because oil brushes, especially the white bristle brushes, are real hair that soaks up the water. This causes the brush to lose its shape and go limp. It's very hard to get a water-soaked brush back to its original shape.

Oil brushes should be stored in a container that holds them securely in place so the points and chisel edges won't be bent or otherwise damaged.

If you have a brush that is out of shape from pushing against something, try dipping it quickly in almost-boiling water. Then pull the bristles back into their original shape and allow the brush to dry. This usually fixes the brush.

materials

Setting Up an Oil Palette

I use disposable palette paper for both acrylic and oil (see page 9 under "A Few More General Supplies"). Look for paper with a slick shiny surface so the oil paint won't soak in. Glass or hard plastic palettes are fine, but these have to be scraped and cleaned.

Set out your oils any way you find comfortable. Many artists like to lay out paints from light to dark. Whatever method you choose, you'll find that if you set up your palette the same way each time, you'll know where the colors are as you work.

Lay your colors on a side of your palette so you have room in the middle for mixing. Avoid laying your colors so close together that it's difficult to pick up one color without getting into neighboring colors.

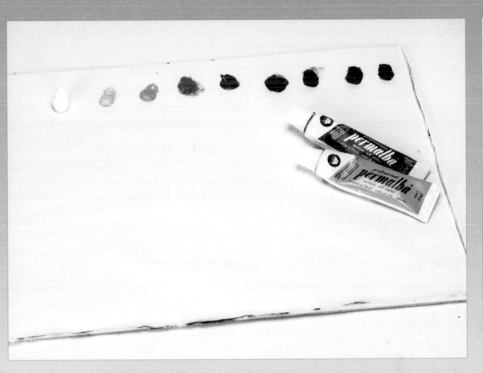

Martin/F. Weber Damar Varnish

For oils, I prefer Martin/F. Weber Damar Varnish. Whatever varnish you use, make sure it's appropriate for oil paint. A water-based varnish pools as you brush it over oil. The choice of matte, satin or gloss finish is up to you.

Permanent varnish, such as Damar Varnish, should not be applied until the paint has completely cured (dried). Premature varnishing can cause the paint to crack. Most manufacturers suggest waiting 6 to 12 months. Since I don't use heavy paint, I usually varnish after 2 or 3 months.

You may spray on a retouch varnish before an oil painting dries. Retouch varnish is meant to be painted over, so you can spray and paint several times. Just remember that retouch varnish isn't meant to do the job of permanent varnish.

acrylic or oil?

Acrylic and oil are two very different types of paint and require two entirely different approaches. Let's explore the differences.

acrylic

Acrylic paints dry quickly—almost as soon as they're applied to the surface—so you have very little blending time. If you work quickly or use a medium that retards the drying, you can do some blending between colors, but more often you'll achieve the appearance of blending by adding several layers of thin color over a dry basecoat. Once you get the hang of this, you'll find it easy to adjust colors and lay on dark values and highlights. If you're new to acrylics, I encourage you to think of this quick drying time as a help rather than a hindrance.

Many acrylic artists use a medium to retard drying time. I've tried some of these mediums, and they're fine to use, but I usually prefer plain water for my medium. I like the paint to dry fast so I can quickly add another layer over the basecoat, and I find acrylic paint dries faster with water. Also, my work is a bit loose, and some of my acrylics look a little like watercolor, so I like the thinner wet paint in many areas.

The general procedure with acrylics is to apply a basecoat in the middle color value on the area where you're working. You then add a wash or glaze of the darker values in their appropriate places. Then you add the highlights. One exception to this is the tree and bush foliage for which I apply the dark values first, working them the same as I would in oil. You then build up the medium and light values, allowing some of the dark basecoat to show through.

oil

Oil paint stays wet for a long time, which gives you time to blend colors. You'll usually begin with the darkest values in any given area. Next you'll pick up the medium values, blending them into the edges of the dark so as not to lose either the medium or dark values. Last, you add a strong light value over the medium values.

If you lay down a light or medium basecoat, you'll find it very difficult to lay a strong dark on top. What will happen is that you'll pick up the wet light value beneath, and it will mix into the dark, weakening its value. Of course, there are exceptions to this order of proceeding from dark to medium to light, but this is generally how you work with oils.

Be aware that dark values in oils are very strong and can take over the medium and light values if they're applied too heavily. A rule of thumb is to apply dark values thinly and light values thickly.

color

color value

Color value simply refers to how light or dark a color is. For example, you may refer to the color blue, but you haven't communicated whether the blue is a light or dark value until you further describe it. By adding white to the blue, you can have a whole range of lighter blue color values. By adding a darker blue to the original blue, you get a darker range of blue color values. (Note that to darken values, you must stay within the same color family.)

Values are important in painting because they help to place objects in perspective. They let us know where we are in the scene. When painting a landscape, we want to show depth. We want a feeling of being able to walk into the scene—a feeling of realism. The further away objects are from you in a painting, the lighter in value they should be. The sky should be the lightest value in the painting because it's the farthest thing from you. As you come forward to distant hills or trees, the values should be darker than the sky and lighter than the hills or trees, which are closer to you. Dark and bright values seem close; the lighter values seem to recede. Be aware of values as you paint, and your work will look more professional.

Color values can also help create a center of interest. Light against dark pulls your eyes to that spot. Pick out an area in your painting where you want everyone to look first. That area will be your center of interest. In that area, have some of the painting's darkest values close to the lightest values. That contrast pulls the viewer's eyes to the spot, helping to create a good focal point.

color mix possibilities

With both acrylics and oils, you can mix an array of colors with just a few starter colors. Below you see the many greens I quickly achieved with four oil colors: Indanthrone Blue, Cadmium Yellow Medium, Cobalt Turquoise and Titanium White.

The more Indanthrone Blue, the darker the green. The more Titanium White and Cadmium Yellow Medium, the lighter the green. Cobalt Turquoise makes the greens brighter.

Experiment with these or similar colors to see how many greens you can achieve. Being familiar with green mixes is very helpful when you're painting landscapes.

Green Mixes

All these greens were created with brush mixes of Indanthrone Blue, Cadmium Yellow Medium, Cobalt Turquoise and Titanium White.

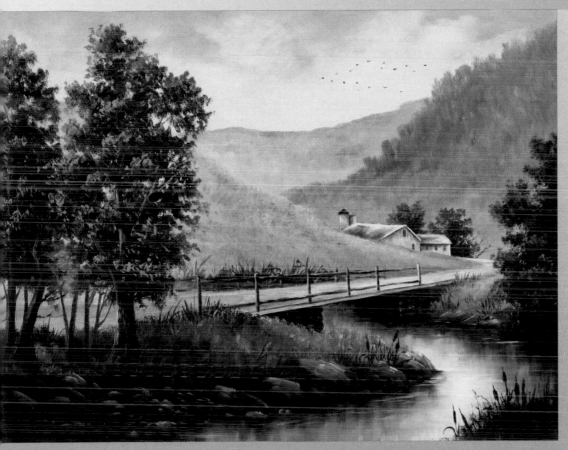

Color Values Establish Depth and a Focal Point

Note that the sky has the lightest value. As you move forward to the most distant hill, the value darkens, and the next closest hill is darker yet. Very dark values are in the forground. This progression of light-to-dark values establishes depth.

Also note that the dark values in the trees behind the barn and the dark shading beneath the bridge set off the light values of the buidings, which are the focal point. Photo from "The Road Home," pages 128-29.

techniques

brush mixing

Whether working in acrylic or oil, I like to brush mix my colors. Brush mixing gives you color variations, which, I think, add a realistic look to paintings.

I do lots of color correcting right on the canvas when I feel the color I mixed isn't quite right. For instance, if I've mixed a blue for the sky and, after I begin painting, I feel the mix is too blue, I simply pick up white and brush right on top of the blue mix on the canvas. In this manner you can adjust your colors as you go.

As you gain experience brush mixing, you'll learn how much to pick up of the various colors. You'll learn which colors are strong (so you need very little) and which are weak (so you need more).

Brush mixing speeds your painting and saves you paint. Many times I've watched students who simply will not brush mix using a palette knife to make a huge pile of paint that turns out to be a totally wrong value. Too often, all they needed was a brush load of color. A few swipes of the brush in the colors to be mixed would have yielded the color they were looking for.

Below is a demonstration of brush mixing.

1 Pour the Paint and Load the First Color

Pour a puddle of paint for each color in your mix. Dip your brush into the first color. Keep the paint in the bottom of the bristles.

2 Mix in the Second Color

Dip into the second color and mix the two colors together with the brush. Avoid overloading the brush, causing the paint to go up and over the ferrule.

glazing

A glaze (sometimes called a wash) is simply a thin coat of transparent color applied over a dry basecoat in order to change the color of the basecoat. It's applied thinly, so you can see some of the original color.

Glazing works well with acrylics because the paint dries quickly and you're able to apply another coat very soon. Glazing is often used in my acrylic projects—it's my standard procedure for applying acrylic shading.

Glazing can be very useful with oils as well, but the drawback is that the first layer of paint must be dry before glazing can be applied. This is fine if you're taking several days to do a painting, are allowing for drying time and are planning on the glazing to finish the painting. But most paintings I teach are intended to be completed in one day, so there's no time to apply glazing. For this reason, I don't use glazing in my oil paintings.

Acrylic Glazing

On the left you see a base acrylic color, Baby Blue. On the right the Baby Blue has been glazed with thinned Williamsburg Blue.

Oil Glazing

On the left you see a base oil color mix of Burnt Umber + Titanium White. On the right the base mix has been glazed with thinned Burnt Umber. Glazing can be an effective technique with oils, but because oils take so long to dry, I do not use oil glazing for projects in this book.

fan brush foliage (for oils)

In my oil painting demonstrations, I frequently refer to the fan brush foliage technique. I paint the basecoat in the darkest value. Then this technique is used to apply the lighter values.

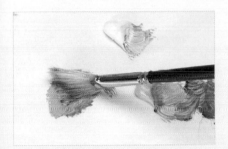

1 Load Brush

Load your mixed colors on one surface only of one half of a bristle fan.

2 Flip Brush

Flip the brush so the paint is on top.

3 Press Lightly on Corner

Start your strokes just beyond the dark basecoat. With the paint on top, press down lightly on the brush corner.

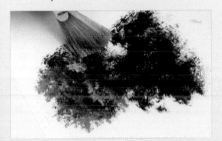

4 Flick Brush

Flick the brush down in a quick stroke. Compare the appearance of corner bristles to the previous step.

5 Work in Clusters

Work the strokes in clusters so light fades into dark, light fades into dark, and so forth.

6 Take a Closer Look

Here are the strokes without the basecoat. The strokes on the left are spotty and unclustered. The strokes on the right are preferred. See how they overlap to form leaf clusters

fan brush grass (for oils)

For the fan brush grass techniques, start with darks and finish with lights.

1 Load Brush

Load about half the brush. This helps you achieve straight grass-like strokes. Painting with the brush center creates curved "rainbow" strokes.

2 Stroke in the Basecoat

Set the brush down lightly with the paint on the bottom. Base with short downward overlapping strokes that follow the ground contour. Vary the color.

3 Add Lighter Texture

Load a lighter color. Flip the brush so the paint is on top. Press the bristles lightly so they bulge a bit. Flick down quickly. Work off the top of the bristles with the brush standing up.

light

When painting, the first thing to think about is the direction of the light. In a landscape, whether real or a painting, the light is coming from the sun or from the reflected light of the moon. Sometimes you have man-made light as well as the light coming from the sky. For example, you might have light in windows or light from a lighthouse.

Learn to think about how the light affects the objects in the painting. Be consistent with your light direction. Keep in mind that light throws shadows directly opposite the light. Working light and shadows in a believable manner adds interest and realism to your painting.

Light won't look light unless it's backed with dark. In other words, for good light effects, you need contrast. Many times I've helped a student trying diligently to get more light on their clouds. They keep adding more light color, to no avail. I'll say, "Don't add more light to the clouds; add more dark around the clouds." By adding more of the darker values (which had been lost by overblending), the light clouds suddenly appear. Contrast is the name of the game.

The importance of contrast holds no matter what area of the painting you're working on. Be sure you have enough dark surrounding your light area for the contrast to be strong. Then your light areas will shine!

Here are a few project photos that demonstrate good light effects.

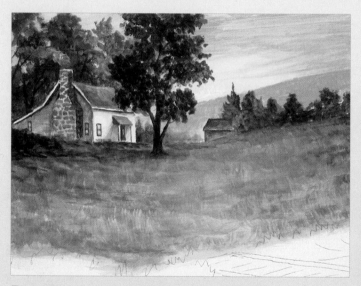

Focal Point: Example 1

Notice that the lightest area in the sky is against the dark tree and the dark tree is close to the light-value house. The house also has dark trees behind it. These light and dark areas draw your attention to the house, which is the center of interest.

Photo from "October Evening," pages 40-51.

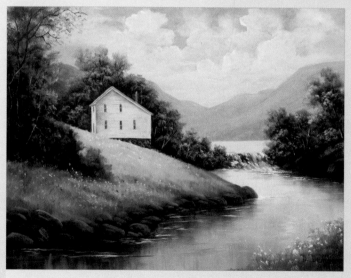

Focal Point: Example 2

Here you can see that the lightest area of the grass is by the building and the building is the lightest thing in the painting. There is enough dark surrounding the building to create a nice focal point.

Photo from "Warm Summer Days," pages 92-103.

Lighting on Grass

In this photo you can see how the grass basecoat colors varied from light to dark as they were laid in. Lighter values were established in the center of the painting and darker toward the bottom, sending your eyes back into the painting. The blue flowers act as highlights. These can be flicked in over any base dark enough to show a lighter value. The paint must be on top of the brush. Stand the brush up and quickly flick down.

Photo from "Summer Showers," pages 30-39.

Lighting on Clouds

Here you see extra highlighting being added to the clouds. The highlight should begin slightly beyond the cloud edge. Softening and blending the bottom of the highlight into the cloud sets the values together nicely. The cloud values under the highlight must be dark enough to let the light edge show.

Photo from "Dawn at Brooks Branch," pages 52-65.

Lighting on Water

Extra shine may be added to any water with a few downward strokes of highlight. Sometimes straight white makes the shine; sometimes another very light value is used. For the shine to work, there must be enough dark values against it for contrast. Again, there is no light without dark.

Photo from "Peaceful Winter Night," pages 104-115.

Lighting on Trees or Bushes

For strong lighting on trees and bushes, begin just outside the edges of the dark basecoat and tap in the outside edge of a leaf cluster. This is where the light hits, so use lots of paint. As the the cluster recedes from the light, it gradually becomes darker, so use less paint, allowing more basecoat to show. The light at the cluster base disappears, so this area is quite dark. Then begin another cluster and repeat the process. Remember, when you're dealing with strong side lighting, the entire tree or bush will be lighter on one side and more shadowed on the other.

Photo from "Paradise Park," pages 66-79.

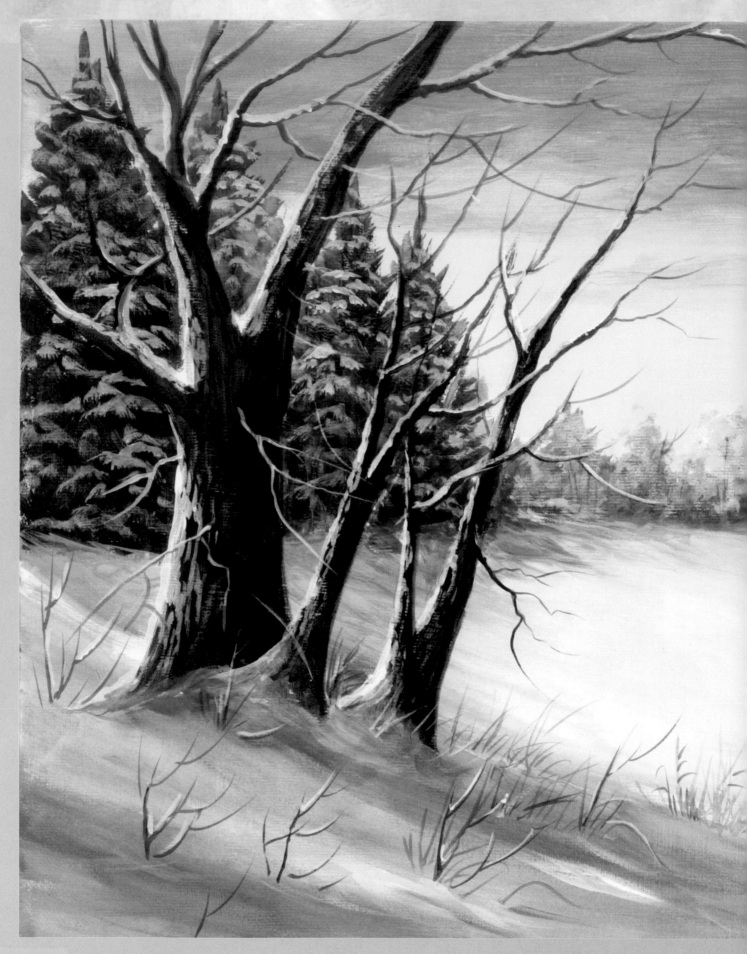

winter trees

evening light from the left onto snow

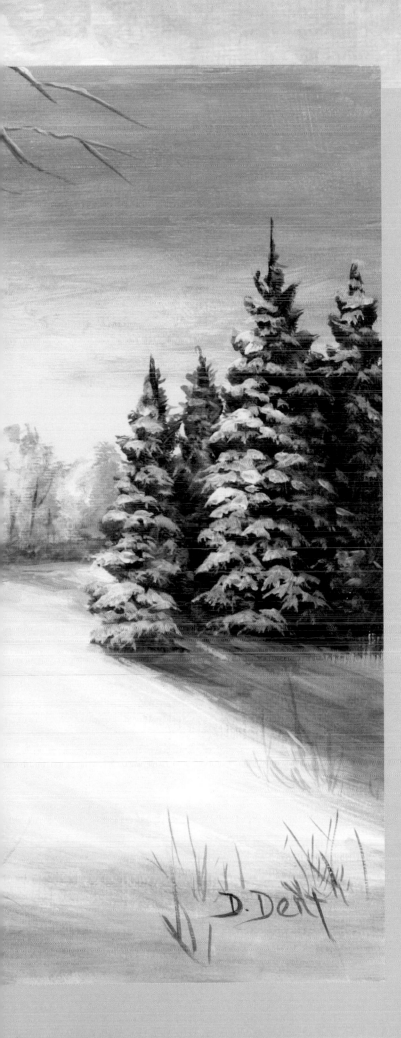

This little scene should not be too difficult to paint. It's rather simple, yet I like the patterns the dark trees make against the background.

The light is obviously from the left with the shadows swept out to the right and away from the light source. I love to paint shadows in winter scenes with their contrast of blues or lavenders against sunlit snow.

The first thing in this painting that catches my eye is the yellow in the sky. Working lavenders close to this yellow creates a nice complementary color scheme. The dark green trees and the dark trunks and limbs of the foreground trees set off the sky. Without those dark objects, the sky wouldn't be nearly as interesting.

Although I painted this scene months ago, as I'm typing these words today, I'm remembering a January sky from just a few evenings ago that looked very much like this.

Black Forest Green

Black Plum

Burnt Umber

Cadmium Yellow

Titanium White

All paints are DecoArt Americana Acrylics

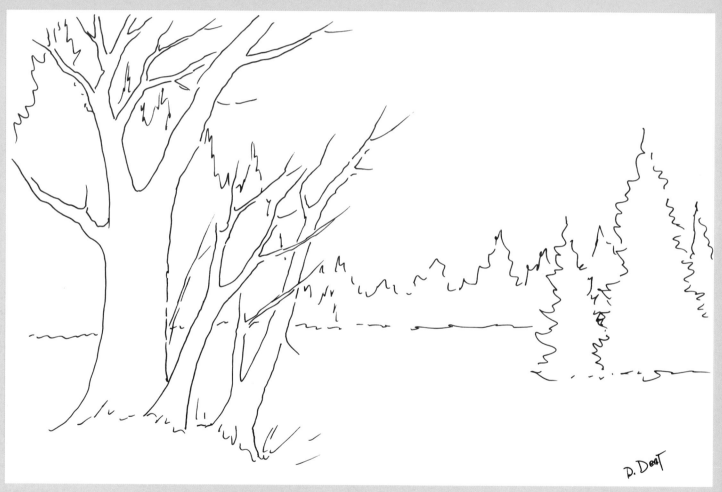

D. Dent

PATTERN

This pattern may be hand-traced or photocopied for personal use only.
Enlarge at 190 percent to bring up to full size.

Deep Midnight Blue

Payne's Grey

Royal Purple

Russet

materials

Surface

Stretched canvas, 11" x 14"
(28cm x 36cm)

Martin/F. Weber Museum Emerald Brushes

- ¾-inch (19mm) flat wash/glaze, series 6210
- No. 8 filbert, series 6204
- No. 10 flat, series 6202
- No. 2 liner, series 6206

Other Materials

- White gesso
- 2-inch (51mm) disposable sponge brush
- Tracing paper
- Black graphite paper, tape and stylus, pen or pencil
- Brush basin
- Palette
- Paper towels
- DecoArt Americana Sealer/Finisher

a quick look at lighting and values

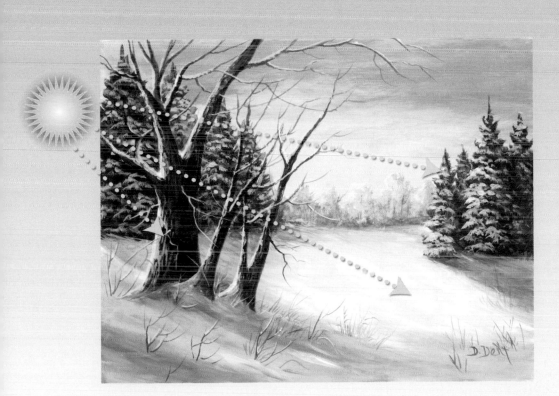

SEASON
Winter

TIME OF DAY
Evening

LIGHT SOURCE
From the left

Use this black-and-white photo of "Winter Trees" to help you understand the relative color values in the painting without the distraction of color.

As the sun and arrows indicate, the light comes from the left.

1 Brush in Lower Sky

Base the canvas with gesso and transfer the pattern (see pages 8-9). Using a ¾-inch (19mm) flat wash and Titanium White + Cadmium Yellow, brush in the lower sky. You may paint over the trees a bit. Let the colors vary and allow the paint to thin out where it will blend with the upper sky.

2 Brush in Upper Sky

Using the same brush loaded with Titanium White + Royal Purple + a little water, brush in the upper sky. As you approach the yellow, stretch the paint out and use more white so the colors appear to blend. If necessary, pick up a bit of Titanium White + Cadmium Yellow to blend over the purple. In skies, a bit of streakiness is acceptable.

TIP

For a good blended look, you sometimes need to work several thin layers of paint on top of each other, allowing for drying time between. For example, you may need to work in layers to achieve the best effect for the steps on this page.

3 Add Layer to Upper Sky

Make sure the sky is dry. Then brush thinned Titanium White + Deep Midnight Blue over the upper sky, but don't try to completely cover the first paint layer.

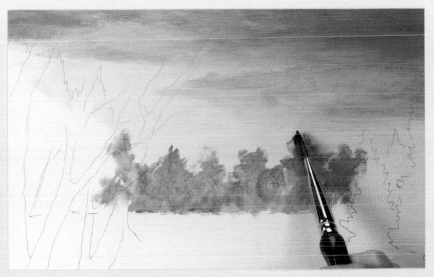

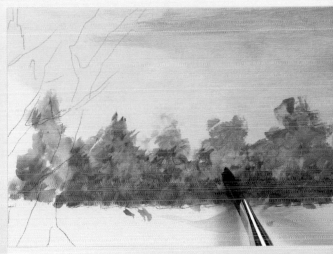

4 Tap in Trees

Loosely tap in the background trees with the side of a ¾-inch (19mm) flat wash and Royal Purple + Black Plum. Some trees will be lighter and some darker. Tap in a bit of Titanium White to soften.

5 Add Darker Values

Add darker values toward the tree bottoms with touches of thin Deep Midnight Blue and varying values of Royal Purple + Russet.

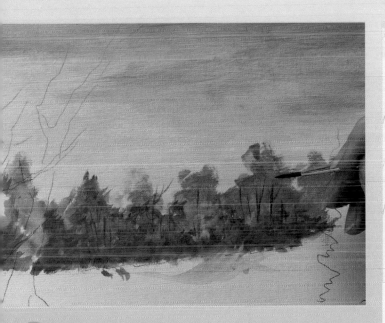

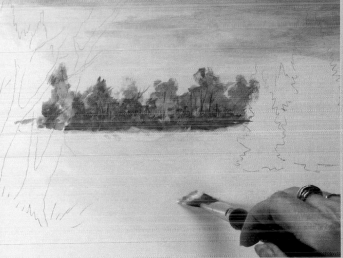

6 Pull in Trunks and Limbs

Using the tip of a no. 2 liner and Deep Midnight Blue + a bit of Russet, add a few trunks and limbs.

7 Begin Snow

Using a ¾-inch (19mm) flat wash and Titanium White + Cadmium Yellow, paint light snow under the trees where the pines will be added.

25

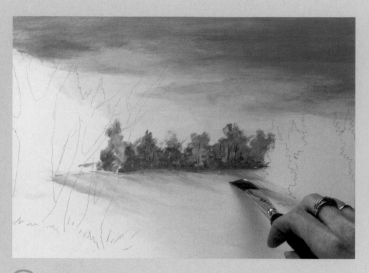

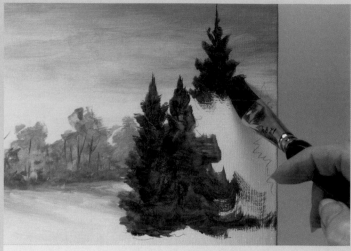

8 Pull Tree Shadows

Still using the flat wash, pull out shadows with varying values of thin Royal Purple + Deep Midnight Blue + Titanium White. Pick up a bit more white and blend the shadow edges over the snow.

9 Block in Pines

Using the same brush, block in the pine trees with very dark Black Forest Green + Russet. Just block in general shapes, some darker and some lighter. Work with the side of the brush, angling upward to get the shape of the branch.

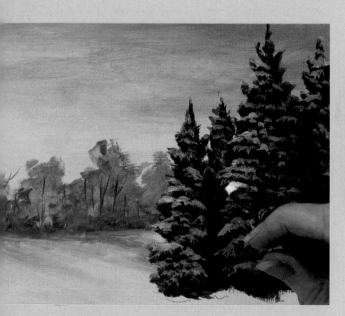

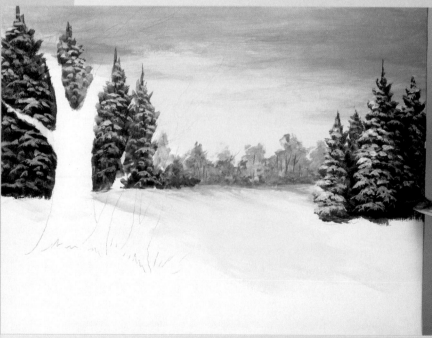

10 Tap on Snow

Tap snow on the trees with a no. 8 filbert and Titanium White. Use the chisel edge, and rock the brush a bit. Paint one tree at a time, keeping in mind which tree you want in front of other trees. The tree in front has more snow on the outside edge (you'll need to add layers). This keeps the trees separate. Be sure you leave some of the green of the tree showing.

11 Add a Purple Wash

Using the ¾-inch (19mm) flat wash, add a thin wash of Royal Purple on the right of some pines.

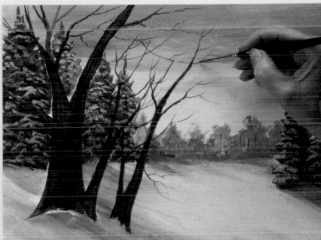

12 Layer in Snow Shadows

Using the same brush and Deep Midnight Blue + a touch of Titanium White, brush in snow shadows under the pines and into the foreground. You'll probably need to apply about three layers. Soften the edges with water or more white.

13 Paint Foreground Trees

Using a no. 10 flat and varying brush mixes of Payne's Grey + Russet + Black Plum, block in the large foreground trees. This will take several layers. Use the chisel edge of the brush to create a bit of streakiness resembling bark texture. Pull out the smaller limbs with a no. 2 liner.

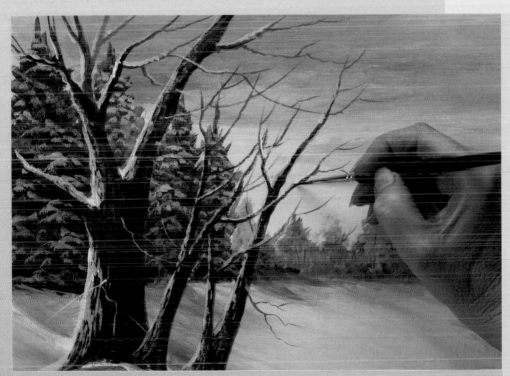

TIP

When doing line-work for thin limbs, be sure the paint is very wet—an inklike consistency. Stand the brush straight up and draw with the tip. Apply more pressure for thick limbs and less pressure for thin limbs.

14 Add Snow on Tree

With a no. 2 liner and Titanium White, use short, choppy strokes to add snow on the left of the trunks. Let the choppy strokes fade out as you move toward the center of the trunk. Also lay snow on top of the limbs. Be sure to leave some of the limb showing, and don't feel you need to add snow to all the limbs. Pull out a few white limbs over especially dark areas.

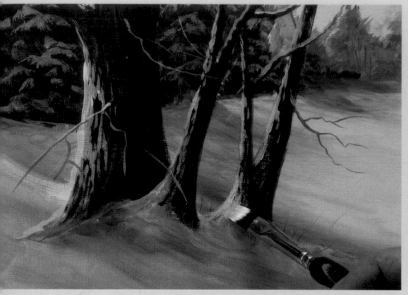

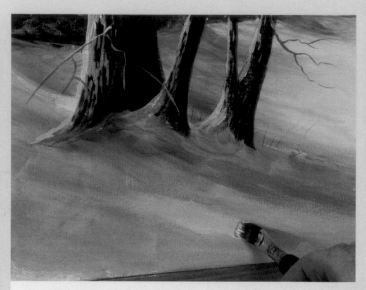

15 Brush Snow up Trunks

Using a no. 10 flat and Titanium White + Deep Midnight Blue, brush up some snow on the left side of the bases of the trunks. Soften the edges.

16 Add More Snow Highlights and Shadows

Using the no. 10 flat, brush in additional snow highlights with Titanium White and additional shadows with Deep Midnight Blue + Titanium White.

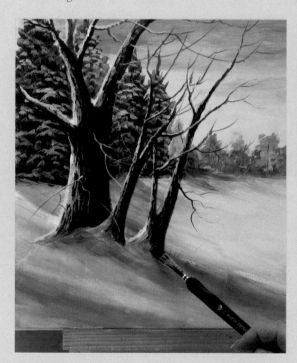

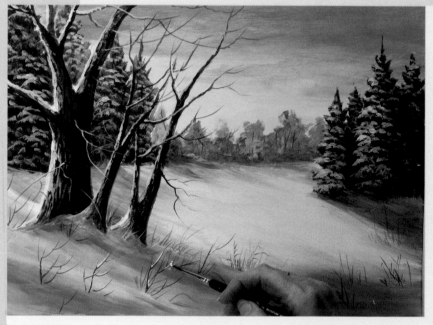

17 Add Dark Glazing

Add thick glazes of Royal Purple + a touch of Titanium White to the darker snow, using a no. 10 flat. Run glazing up some trunks, on the right of the snow.

18 Add Weeds

Flick up weed clusters in the foreground with a no. 2 liner. Use thin Royal Purple and Payne's Grey + Burnt Umber, varying the proportions. The darker weeds are closer to the front. Paint some Titanium White weeds in the shadowed areas, and add snow to some of the larger weeds.

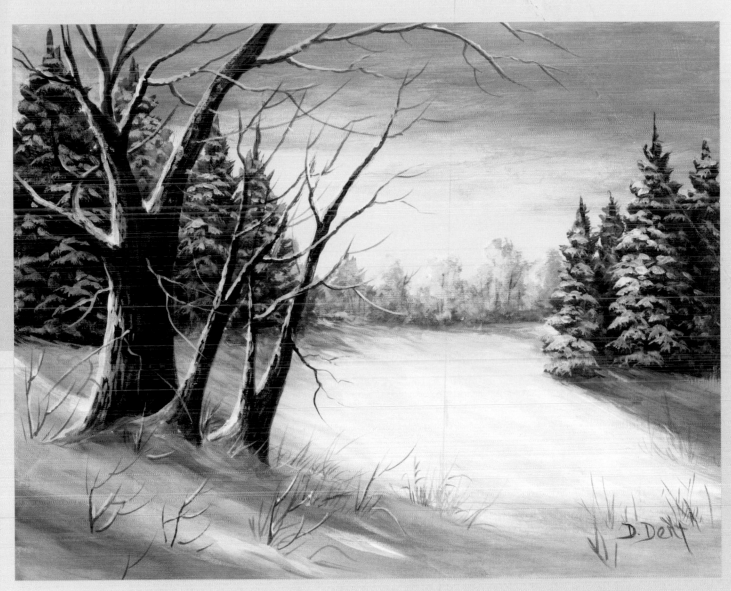

Take a Closer Look

Look at the painting in the last step to the left. I like how the snow shadows and dark trees in the foreground bring this part of the painting forward. The pines form a nice dark area in the middle ground where the value is more important than the shape. The sky has a good bright area against the complementary lavender, accenting the light effect. The clouds have a nice streaky look.

On the other hand, the bright area of snow seems a bit too yellow. I want to soften this with a thin layer of Titanium White. The big trees in the foreground could use a few more limbs, and the purple of the background trees could stand some softening with additional Titanium White. Finally, even though the shape of the pines is secondary to the color value, I want to work with the shape of the pine closest to the middle on the left, as it seems to have a chunk missing from its right side. These adjustments have been made to the painting above.

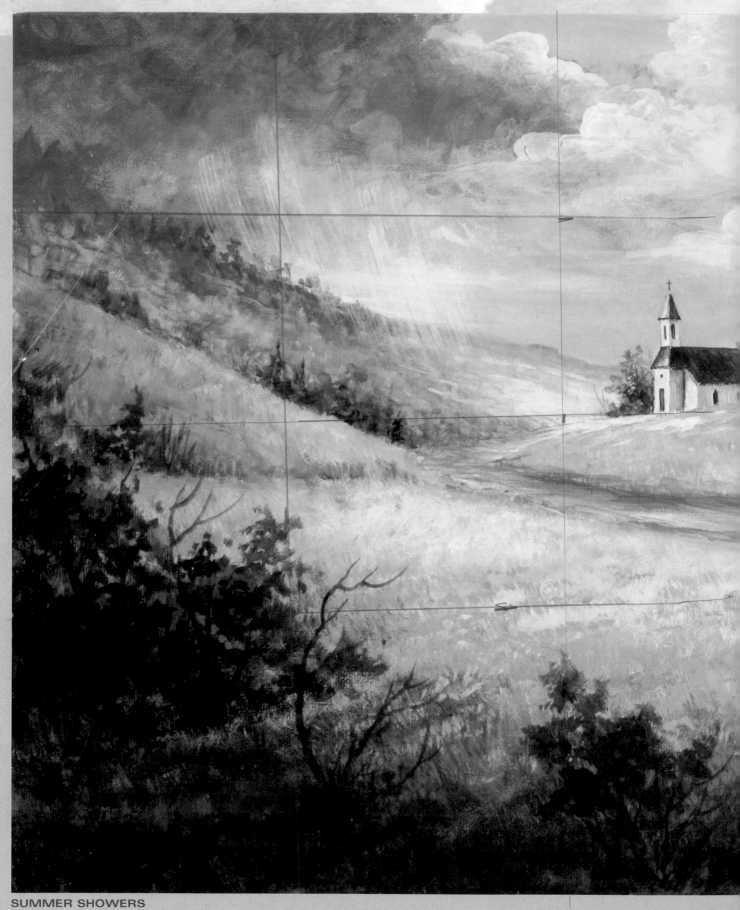

SUMMER SHOWERS

summer showers

light from left through rain

Stormy skies are fun to paint. This little cloud-burst is still off in the distance, and the sun is shining from behind the clouds on the left. Simultaneous sunshine and rain are only slightly unusual. When it occurs, I always run out to see if there's a rainbow.

Little churches such as this one are a familiar sight as one travels around the midwestern North American countryside. I painted this church from a photo I took in Canada. Only the church was in the photo. My imagination added the setting of a windswept hill.

| Black Forest Green | Deep Midnight Blue | Hauser Light Green | Russet |

All paints are DecoArt Americana Acrylics

D. DenT

PATTERN

This pattern may be hand-traced or photocopied for personal use only.
Enlarge at 200 percent. Then enlarge again at 108% to bring up to full size.

Salem Blue	Titanium White

materials

Surface

Stretched canvas, 12" × 16"
(31cm × 41cm)

Martin/F. Weber Museum Emerald Brushes

- ¾-inch (19mm) flat wash/glaze, series 6210
- Nos. 8 & 14 flats, series 6202
- No. 2 liner, series 6206

Dorothy Dent Brush

- Foliage fan (no. 4 bristle fan)

Other Materials

- White gesso
- 2-inch (51mm) disposable sponge brush
- Tracing paper
- Black graphite paper, tape and stylus, pen or pencil
- Brush basin
- Palette
- Paper Towels
- DecoArt Americana Sealer/Finisher

a quick look at lighting and values

SEASON
Summer

TIME OF DAY
Daytime

LIGHT SOURCE
From behind clouds on the left

This black-and-white photo of "Summer Showers" allows you to see the relative dark and light values in the painting without the distraction of color.

As the sun and arrows indicate, the light is coming from the cloudy area on the left.

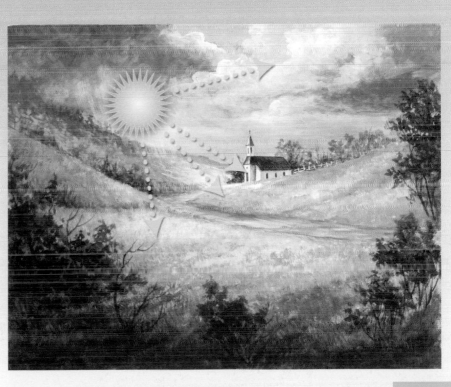

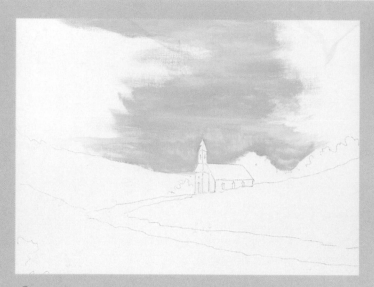

1 Begin Sky

Basecoat the canvas with gesso and transfer the pattern (see pages 8-9). Using a ¼-inch (19mm) flat wash, base the sky in the upper middle area of the painting with Salem Blue + Titanium White.

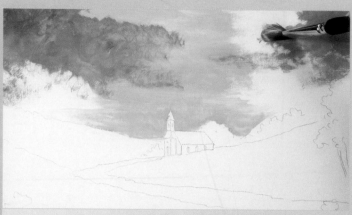

2 "Scrub" in Dark Clouds

Working the bottom corner of the same brush in circular "scrubby" strokes, base in the storm clouds with Deep Midnight Blue + Titanium White. Press down the brush so the bristles are pushed against the canvas. Start in the upper left corner and vary the amount of white for a puffy, layered look.

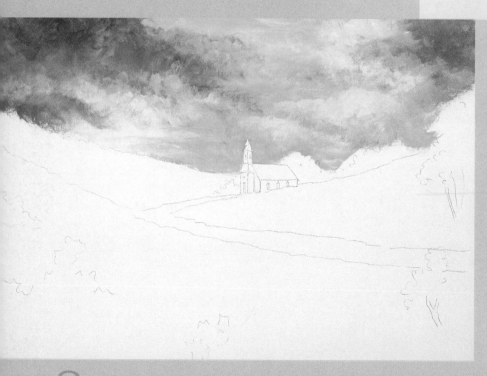

3 Add Gray Clouds

With Titanium White on the dirty brush, fill in the unpainted sky with gray clouds. Use the same scrubby strokes as you did in the previous step. Work over the edges of the dark clouds and across the blue sky.

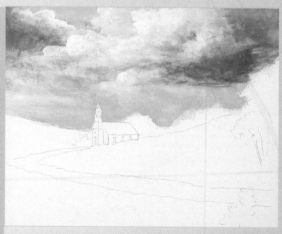

4 Highlight the Clouds

Rinse the brush and, using the same circular, scrubby stroke, apply Titanium White cloud highlights. The light is coming from behind the left clouds, but because it scatters and reflects, you can place highlights almost anywhere, as long as you keep the brightest areas toward the middle. Remember that the highlight helps create the outside edges of the clouds. If you feel you've lost too much of the dark cloud or blue sky, paint it back in. A sky like this can be worked with many layers to achieve the desired effect.

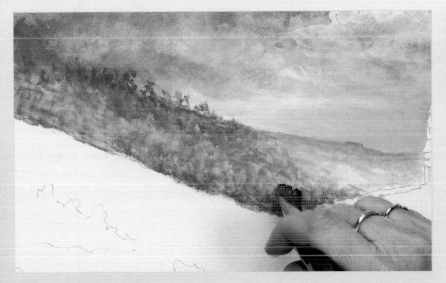

5 Base Distant Ground and Trees

Still using the ¾-inch (19mm) flat wash, base the distant ground with a mix of Hauser Light Green + Titanium White, picking up Black Forest Green + Russet for darker values. Use short, vertical patting strokes. The edge of the hills against the sky should be slightly darker than the sky to delineate between the two areas. Note that next to the church, the hills immediately lighten under the horizon. At the top of the hill to the left, turn the brush to create a line of trees against the sky.

6 Add Blue and Closer Trees

Pick up a bit of Salem Blue + Titanium White and tap in a bluish area in the middle of the hill. Using the bottom corner of the brush, tap in trees or bushes at the bottom of the hill with Black Forest Green + Russet.

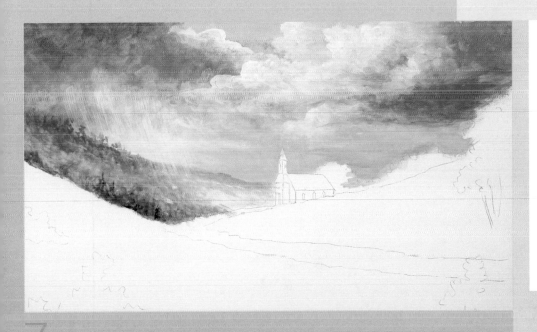

TIP

Remember that you can layer acrylic paints endlessly to achieve the effect you're looking for. Be sure to allow the previous layer to dry before adding another.

7 Pull Down the Rain

Using the flat of the ¾-inch (19mm) flat wash, pull down the rain in Titanium White. Be sure the rain comes out of a dark area of the cloud, and stagger the top of the strokes higher and lower in the sky. The rain must lay over a dark area, or it won't show. Use very light brush strokes, and slant the rain slightly as if it's blown by the wind.

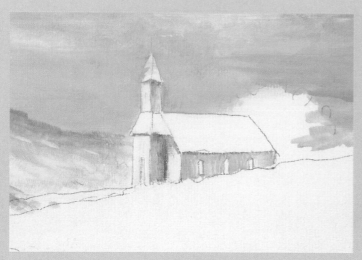

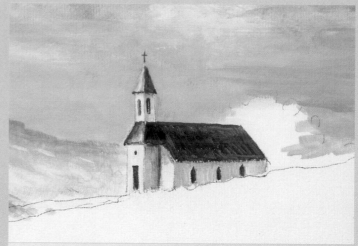

8 Shade Church

Using the no. 2 liner, clean up any stray sky color on the church walls with Titanium White. Add shading on the right sides with varying proportions of Titanium White + Deep Midnight Blue. Make sure the shading delineates the different sides of the church at the corners. Note the dark line in the recessed corner of the church front. Note also how the darker side of the church runs into the lighter front of the church at the corner.

9 Paint Roof, Windows and Door

Continuing with the no. 2 liner, paint the roof with Black Forest Green + Russet + a bit of Titanium White. Don't forget the upper and lower steeple roofs and the cross on top of the steeple. On the left side of the upper and lower steeple roofs, add extra white for a highlight. Paint in the windows and doors with Black Forest Green + Russet.

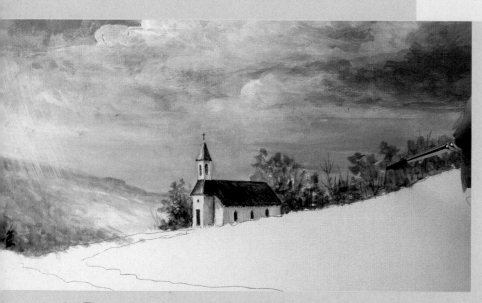

10 Add Foliage Around Church

Using the bottom corner of a no. 8 flat and Black Forest Green + Russet, paint the foliage around and behind the church. The green right up against the church is necessary for contrast so the church won't fade into the hills. Pull in a few trunks and branches with the no. 2 liner.

11 Paint Grassy Bank on Right

Using about half the bristles of a no. 4 bristle fan, paint the right grass bank with Black Forest Green + Titanium White + Russet and with Hauser Light Green + Titanium White. Sometimes pick up a bit of Salem Blue. Use short downward strokes.

12 Paint Grassy Area in Foreground

Paint the remainder of the grassy area with the same brush, colors and techniques as you did in the previous step. Be careful not to paint over the road. Vary the colors, paying attention to light and dark areas of the painting and applying several layers. As you descend to the darker areas, pick up Deep Midnight Blue with your Black Forest Green + Russet.

13 Scatter Wildflowers

Using a no. 4 bristle fan and Salem Blue + a little Titanium White, apply a few short downward strokes to resemble a scattering of blue wildflowers in the middle of the lower foreground.

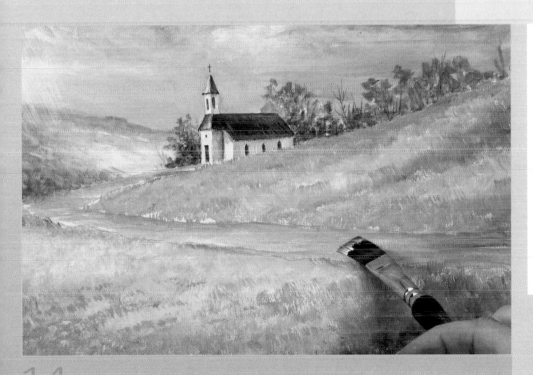

TIP

Be sure the paint is on top of the fan brush when adding flowers or extra grass texture. Stand the brush up and flick quickly down.

14 Base the Road

Using a no. 14 flat with Titanium White + a bit of Russet, paint the road with back-and-forth strokes.

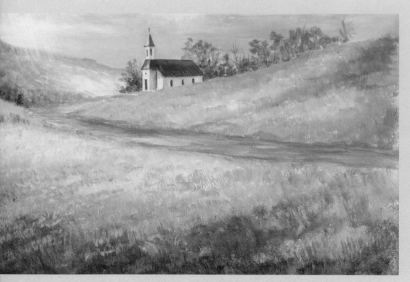

15 Shade the Road

Add shading to the road with Deep Midnight Blue + Titanium White. Overlap a bit into the grass to soften the road borderline.

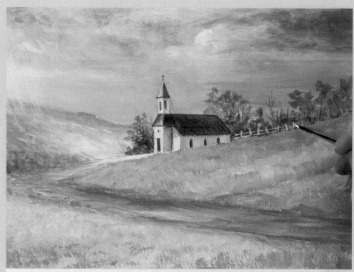

16 Highlight the Road

Using the same brush and Titanium White, highlight the path near the church. This has the double purpose of carrying through the light effect of the bright, sunny spot on the grass behind the path and helping to draw the eye to the church, which is the focal point of the painting.

With a no. 2 liner, paint a fence behind the church, letting it fade into the distant trees.

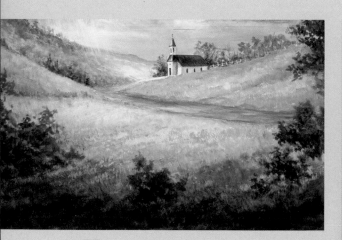

17 Tap in Foreground Foliage

Using the corner of the no. 14 flat and Black Forest Green + Russet, tap in the foliage in the foreground. Occasionally you may want to tap in some Hauser Light Green to break up the darker clusters. Strive for irregularly shaped leaf clusters, vary the color and layer the paint. The bush on the right rising over the road is important; it keeps the eyes from running off the edge of the painting with the line of the road.

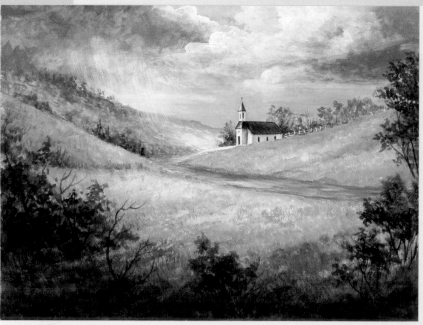

18 Add Trunks and Limbs

Using the no. 2 liner and Deep Midnight Blue + Russet, add trunks and limbs, working in and out of the leaf clusters.

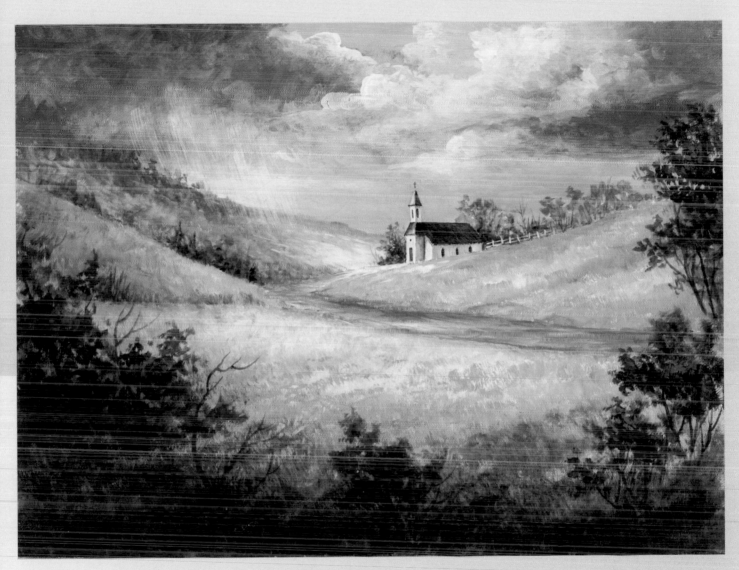

Take a Closer Look

Look at the painting in the last step on the left. I'm pleased with its overall mood. I like the softness in the background contrasting with the dark values in front. I feel the rain and clouds are successful.

I do, however, want to brighten the focal area around the church to help draw the eye. To do this, I can add more highlighting in the grass in front of the church and to the cloud over the church. I can also add another layer of white on the church front. The blue patch of sky to the right of the church has a streaky look that I want to soften. To help with the brightening of the church and the sky, I can introduce the tiniest bit of Peaches 'n Cream. All the adjustments I've mentioned have been to the painting above.

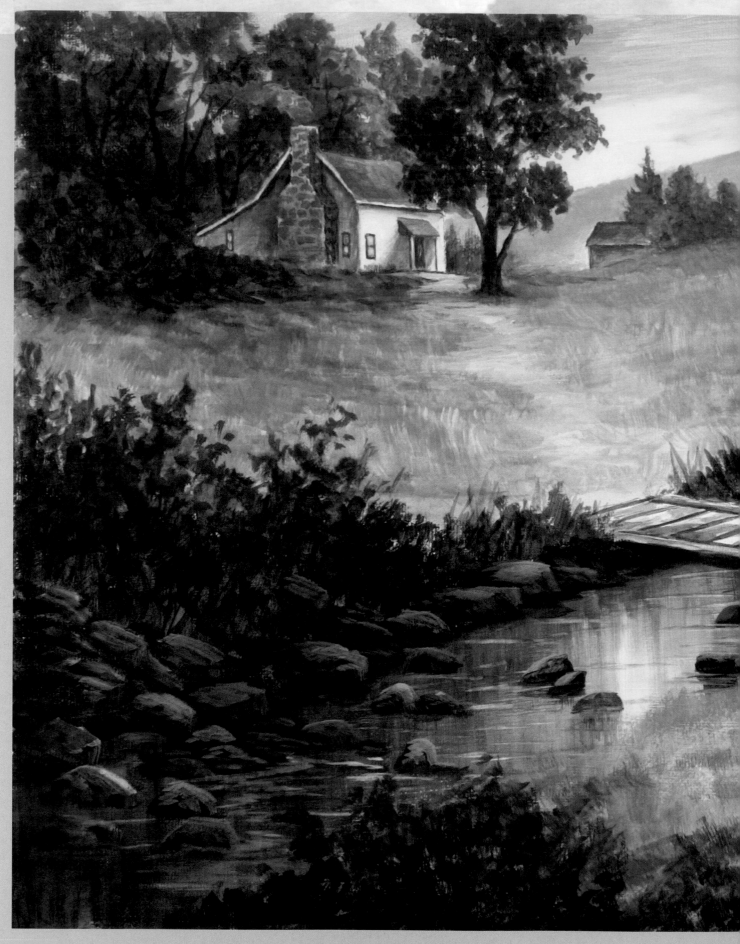

october evening

light from central setting sun

In all landscapes, the sky sets the tone. It establishes the time of day and, as the major light source, the direction of the light. When the sky is full of bright color, we know it's either evening or morning. (Sometimes it could be either.)

Note how the light brightens the right side of the house as well as the right side of the tree foliage around the house. The light continues to play on the ground along the center path and shine down in the water. The path winding toward the house and the light around the path help bring your attention to the house as the center of interest. Even the footbridge points toward the house. The darker values in the foliage and bushes near the edge of the canvas keep our eyes from running out of the painting. Our eyes are drawn to the light in the center, as if by a magnet.

OCTOBER EVENING

Black Forest Green

Burnt Orange

Buttermilk

Cadmium Yellow

Peaches 'n Cream

Russet

Titanium White

All paints are DecoArt Americana Acrylics

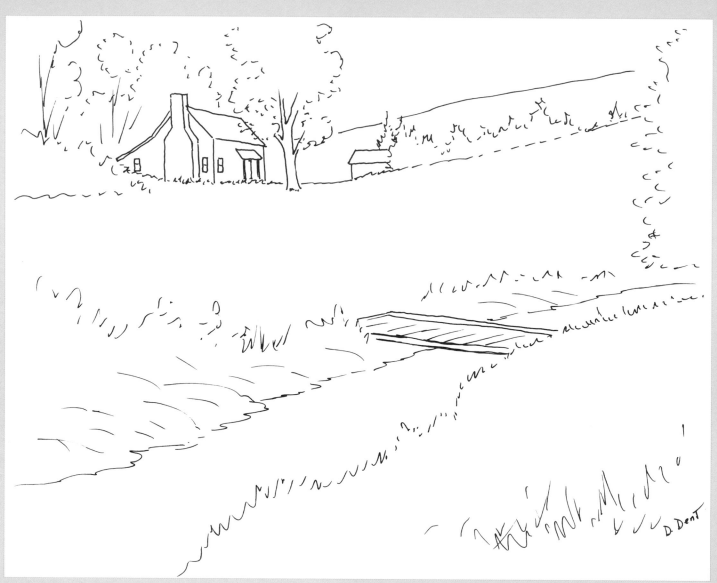

D. Dent

PATTERN

This pattern may be hand-traced or photocopied for personal use only.
Enlarge at 186 percent to bring up to full size.

Camel

Deep Midnight Blue

Honey Brown

Payne's Grey

materials

Surface

Stretched canvas, 11" x 14"
(28 cm x 36cm)

Martin/F. Weber Museum Emerald Brushes

- ¾-inch (19mm) flat wash/glaze, series 6210
- Nos. 8, 10 & 14 flat, series 6202
- No. 8 filbert, series 6204
- No. 2 pointed round, series 6200

Other Materials

- White gesso
- 2-inch (51mm) disposable sponge brush
- Tracing paper
- Black graphite paper, tape and stylus, pen or pencil
- Brush basin
- Palette
- Paper Towels
- DecoArt Americana Sealer/Finisher

a quick look at lighting and values

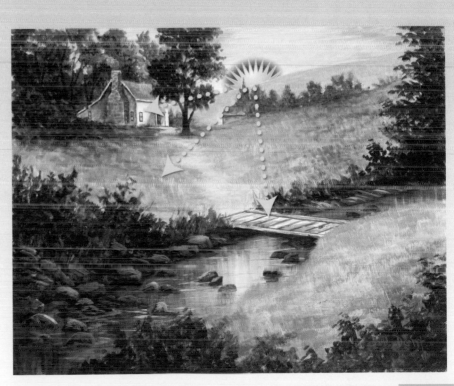

SEASON
Autumn

TIME OF DAY
Evening

LIGHT SOURCE
From the setting sun

This black-and-white photo of "October Evening" allows you to see the relative dark and light values in the painting without the distraction of color.

As the arrows indicate, the light emanates from the sun setting behind the mountain.

1 Paint a Sky of Many Colors

Basecoat the canvas with gesso and transfer the pattern (see pages 8-9). Use a ¾-inch (19mm) flat wash to paint the bottom of the sky with Cadmium Yellow + Titanium White. Add Peaches 'n Cream + Titanium White to the middle sky, blending into the yellow. Paint the top of the sky Titanium White + Deep Midnight Blue, overlapping into the light values. Pick up more Peaches 'n Cream + Titanium White and layer over the bottom of the blue for a blended look.

2 Base the Hill

Still using the ¾-inch (19mm) flat wash, base the hill with Camel + a touch of Buttermilk.

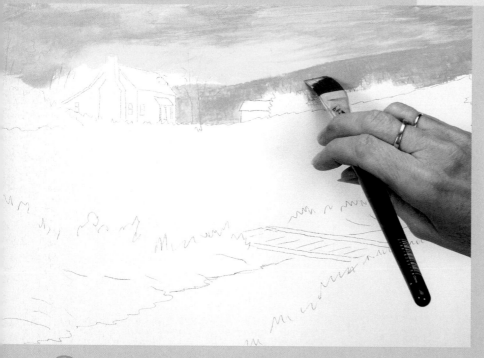

4 Base Trees and Bushes

Move down to a no. 14 flat and base in the dark trees behind the house and the trees and bushes on the right with Black Forest Green + Russet. Use the corner of the brush and leave some sky holes in the trees. Think in terms of leaf clusters. Since this is an autumn scene, it's okay to let the trees look a bit brown here and there.

3 Add Grass Texture

Combine Camel + Black Forest Green to create a dull, brownish green and paint over areas of the hill to suggest grass texture.

5 Highlight Trees

Using the same brush, highlight the trees with Burnt Orange and Burnt Orange + Honey Brown. Keep in mind that the light source is in the middle, so you should highlight the side of the trees closest to the middle.

6 Base and Shade the House

With a no. 8 flat, base the house walls in Buttermilk. Add shading with Deep Midnight Blue and Deep Midnight Blue + a touch of Russet, adjusting colors as needed. Note that the darkest shading is on the left side of the house, under the roof edges and under the porch. Apply shading in layers rather than trying to paint one heavy coat.

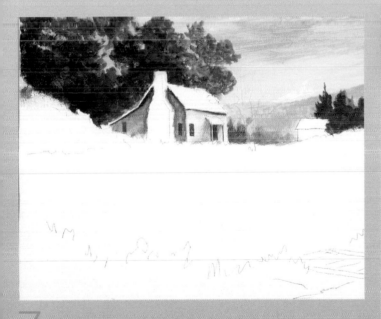

7 Add Highlights, Door and Windows

With the same brush, add Titanium White highlights around the windows and to the right of the door. Switching to a no. 2 pointed round, paint in the door, the porch posts and the windows with Russet + a bit of Deep Midnight Blue. Also use this color to add a line of deep shading right under the roofline.

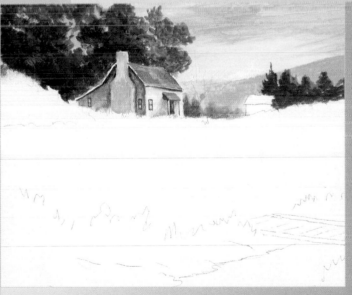

8 Continue with House Detail

Using the no. 2 pointed round, paint the window light with Cadmium Yellow, leaving a dark outline around the windows and through the middle for a pane line. Highlight the porch posts with Titanium White. Switch to a no. 10 flat and base the house and porch roofs in Russet + Titanium White, going darker on the left side of the porch. Base the chimney in Camel.

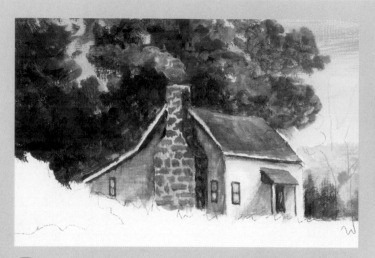

9 Paint Chimney Rocks and Smoke

Still using the no. 2 pointed round, paint the chimney rocks with Russet + Honey Brown. Create irregular shapes, leaving some basecoat for mortar. Make the rocks darker on the right side. The chimney smoke is thinned Titanium White. Also, paint the fascial boards (boards along roof line) in Titanium White.

10 Paint Shed

Paint the shed in the distance with Deep Midnight Blue + Russet and a no. 2 pointed round. The roof is Russet + Titanium White. Add a bit of Deep Midnight Blue to shade. If necessary, highlight the bushes next to the shed with Black Forest Green + Cadmium Yellow to create contrast.

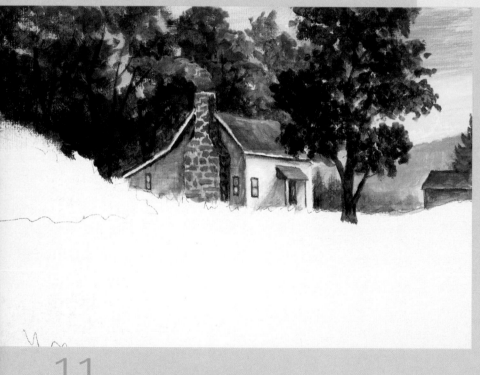

11 Add a Tree, Paint All Trunks and Limbs

Paint the foliage of the tree in front of the house as you did the trees in steps 4 and 5. With the no. 2 pointed round, add a trunk and limbs to this tree and the trees behind the house.

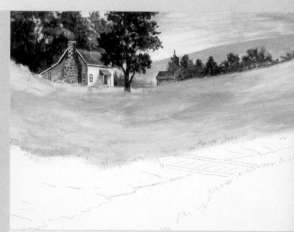

12 Base Middle Ground

Using a ¾-inch (19mm) flat wash, base in the middle ground with Camel. Mix in a bit of Buttermilk in the lighter areas. Paint over the pattern lines of the tree on the far right.

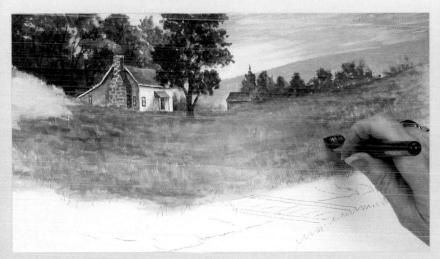

13 Add Colors and Texture

With the same brush, add additional color and grassy texture with a dull green of Camel + Black Forest Green. Paint in short downward strokes, following the slope of the ground. Occasionally add Russet, Camel or Honey Brown to the mix. Paint in several layers, letting the colors overlap each other. Strive for colors flowing into each other without losing the texture.

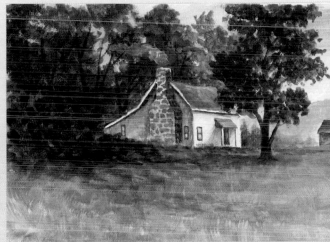

14 Add Bushes on Left

Using the ¾-inch (19mm) flat wash, paint the bushes to the far left with Russet + Black Forest Green. Add touches of Burnt Orange highlights. With Russet + Black Forest Green, add depth to the shaded area around the house and under the tree in front of the house.

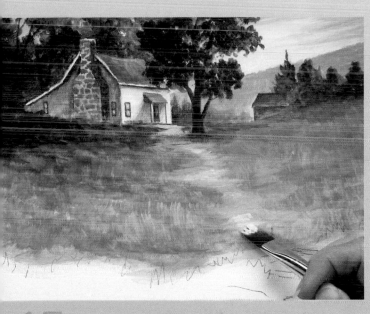

15 Zigzag in the Path

Using the corner and chisel of a no. 14 flat and Buttermilk + a bit of Camel, zigzag back and forth to create the path. If the path covers the tree shadow, add a bit of Russet in that area to darken.

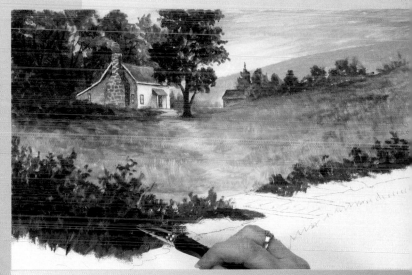

16 Paint Middle Area Bushes

Using the ¾-inch (19mm) flat wash, paint bushes to the lower left and along the bank with Black Forest Green + Russet. Keep them loose and airy toward the top. Add hints of Burnt Orange.

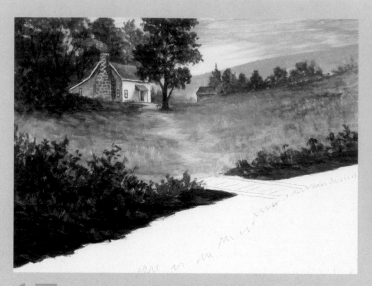

17 Base the Bank

Using the no. 14 flat, base in the rocky bank with Deep Midnight Blue + Payne's Grey + Russet. Vary the colors and work in layers.

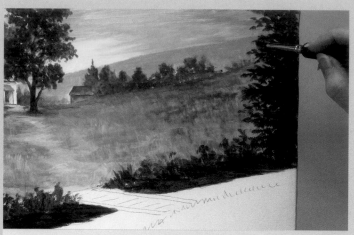

18 Tap in Tree on Right

Using a no. 8 filbert, paint the tree on the far right with Black Forest Green + Russet. Hold the brush with the handle straight out and quickly tap the ends of the bristles, rocking a bit. Connect the tapped areas, but leave a bit of background showing.

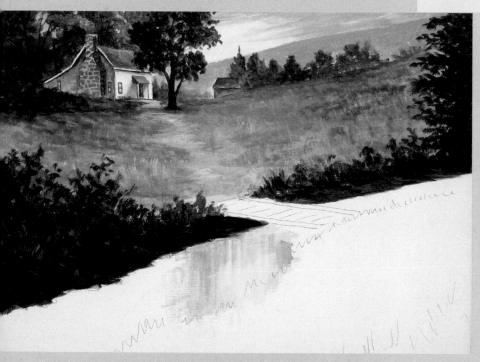

19 Highlight Water

Using the no. 14 flat, paint the water highlight with Cadmium Yellow + Buttermilk, stroking downward. Work some Peaches 'n Cream around the edges. Starting with the highlight keeps the color brighter, so the water will appear to shine.

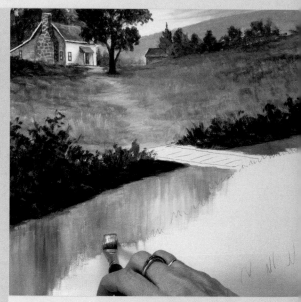

20 Base Remaining Water

With the same brush, now base the rest of the water with Deep Midnight Blue + Titanium White. Remember to stroke downward, letting some dark color fade into the highlight area. Vary the colors a bit for light and dark values.

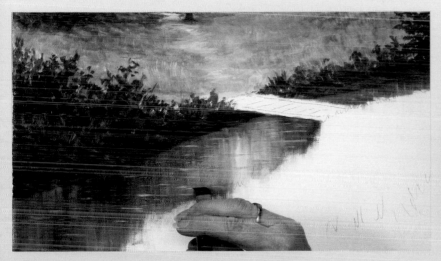

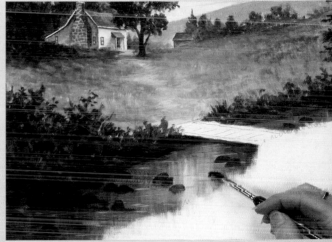

21 Shade and Add Movement Lines

Add shading with downward strokes of Payne's Grey + Deep Midnight Blue + Russet, varying the proportions. Start the strokes at the upper bank. While the paint is still wet, use the chisel edge of the clean, wet brush to create horizontal motion lines, making sure they run parallel to the bottom of the canvas. You will actually be pulling paint from the canvas. When the painted water is dry, add movement lines with Buttermilk.

22 Base the Rocks

Moving down to a no. 8 flat, base the rocks in the water with Payne's Grey + Russet. Create different shapes, and place some coming off the bank and some in the middle of the brook. Make the rocks darker in the shaded areas.

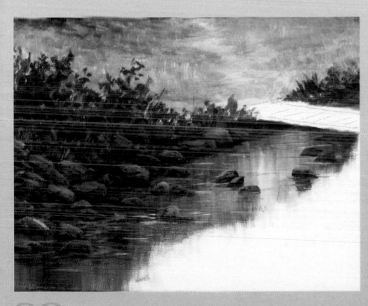

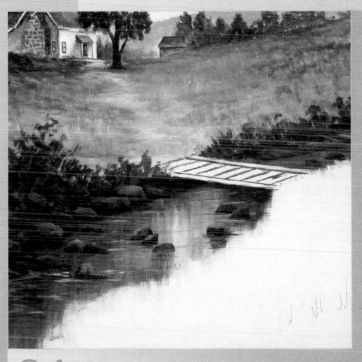

23 Highlight Rocks and Bank

With a no. 8 flat, highlight the tops and sides of the rocks with Peaches 'n Cream and Deep Midnight Blue + Buttermilk. Use the highlighting to "find" the rock shapes, starting at the top and pulling down the sides. Notice that the brightest highlights are in the "shine" area of the water. Also place a light Buttermilk + Deep Midnight Blue highlight on the bank on the far side of the bridge. In the dark areas of the foreground, add a few horizontal movement lines around the rocks.

24 Establish Bridge and Boards

With the no. 8 flat, paint the bridge in Titanium White, mostly to re-establish the line of the bridge against the bank and the water. With Payne's Grey + Russet, edge the bottom of the far rail, the top of the near rail and the cracks between the boards.

49

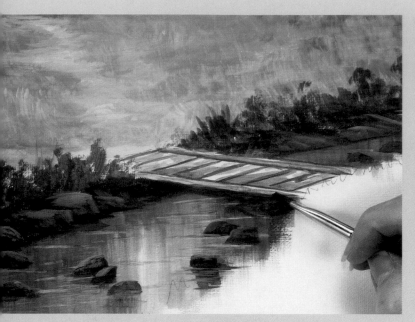

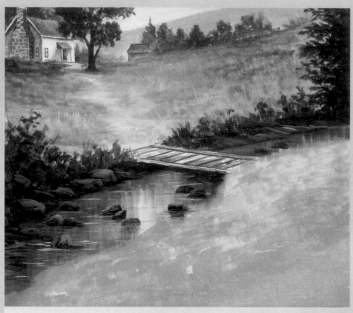

25 Glaze Bridge

With the same brush, glaze in thinned Russet and a bit of Payne's Grey, but don't cover all the white.

26 Base Foreground Grass

With the ¾-inch (19mm) flat wash, base the lower right corner in Camel. Make the color darker as you approach the bottom and the corner.

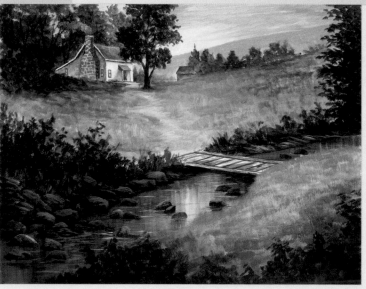

27 Add Texture and Tap in Foliage

Using the same brush, add texture with short, downward strokes of Camel + Black Forest Green + Honey Brown. Work on the ends of the bristles, and let the strokes overlap. Toward the bottom, pick up a bit of Russet on the dirty brush.

With the bottom corner of the same brush and Black Forest Green + Russet, loosely tap in dark foliage in the bottom corner.

28 Enhance the Glow

Still using the ¾-inch (19mm) flat wash, brush in a glaze of thinned Cadmium Yellow on the grass in the center area and on the foreground bank near the bridge. This should be very thin—just enough to add to the glow.

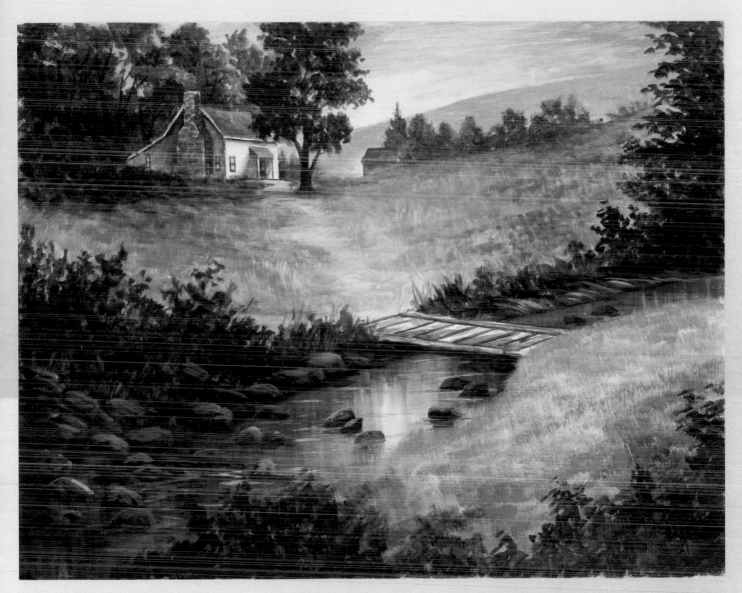

Take a Closer Look

Look at the painting in the last step to the left. I'm happy with the bright spot in the sky and how it lays into the tree foliage next to it. I notice this brightness follows through nicely right down into the water. On the other hand, the dark cloud line seems to follow the line of the mountain too closely. I want to paint it out with a thin wash of Peaches 'n Cream + Titanium White. I'm generally happy with the house, but the chimney and the wall to the left of the chimney need to be toned down with a very thin wash of Payne's Grey. The grass has a few vertical streaky areas that catch my eye. To correct this, I can work over the streaks with the same grass colors. Finally the width of the tree on the right is too uniform from top to bottom, so I want to broaden the base for a more interesting shape. All the adjustments mentioned here have been made to the painting above.

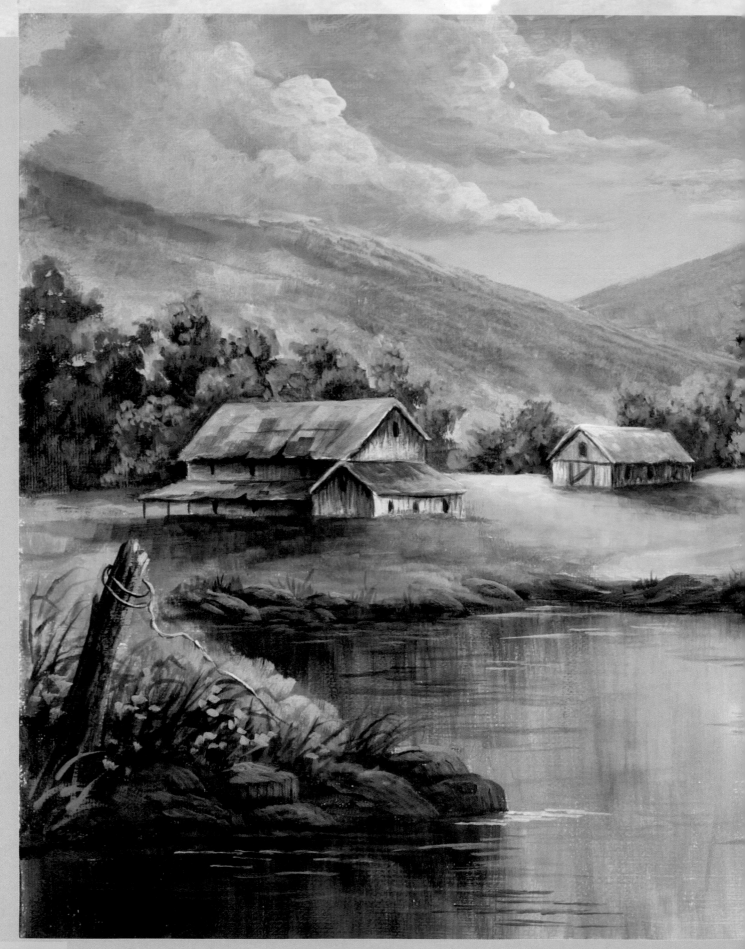

dawn at brooks branch

light from central rising sun

This painting began with photos of old barns that I took in North Carolina. I added the rest of the landscape to complement the barns. The dawn sky sets the tone for this scene, with the glow hitting the barn tops and tree edges and reflecting in the water. Carrying the sky colors this way right down through the painting pulls everything together. Note how the shadows fall to the right on the right side of the painting and to the left on the left side. This assures that the light is indeed coming from the center back of the scene.

DAWN AT BROOKS BRANCH

Black Forest Green

Buttermilk

Cadmium Yellow

Deep Midnight Blue

Titanium White

All paints are DecoArt Americana Acrylics

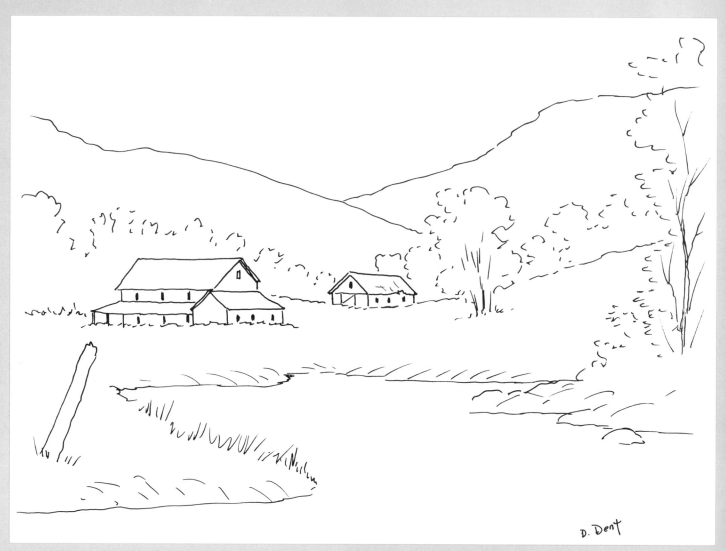

D. Dent

PATTERN

This pattern may be hand-traced or photocopied for personal use only.
Enlarge at 195 percent to bring up to full size.

Hauser Light Green

Payne's Grey

Peaches 'n & Cream

Russet

materials

Surface

Stretched canvas, 11" x 14"

(28 cm x 36cm)

Martin/F. Weber Museum Emerald Brushes

- ¾-inch (19mm) flat wash/glaze, series 6210
- Nos. 8 & 14 flat, series 6202
- No. 2 liner, series 6206

Other Materials

- White gesso
- 2-inch (51mm) disposable sponge brush
- Tracing paper
- Black graphite paper, tape and stylus, pen or pencil
- Brush basin
- Palette
- Paper towels
- DecoArt Americana Sealer/Finisher

a quick look at lighting and values

SEASON
Spring/Summer

TIME OF DAY
Early morning

LIGHT SOURCE
From the sun, rising behind the mountain

This black-and-white photo of "Dawn at Brooks Branch" allows you see the relative dark and light values in the painting without the distraction of color.

As the arrows indicate, the light emanates in all directions from the sun, which is rising over the mountains.

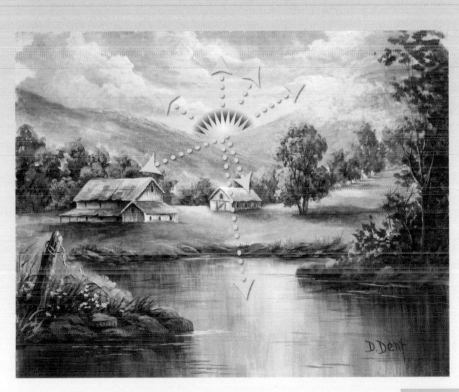

1 Base the Sky

Basecoat the canvas with gesso and transfer the pattern (see pages 8-9). Using a ¼-inch (19mm) flat wash, base the sky in Titanium White + Peaches 'n Cream.

2 Add Clouds

Add clouds with Titanium White + Deep Midnight Blue on a ¼-inch (19mm) flat wash. Occasionally add a touch of Payne's Grey. Apply the paint with the bottom corner of the brush, moving in a circular motion. Use lots of white to keep the clouds from becoming too dark, and apply in several layers. If necessary, soften the cloud edges with Titanium White + Peaches 'n Cream.

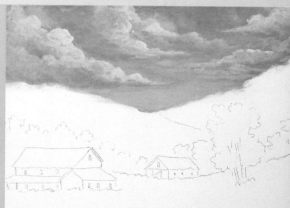

4 Brighten the Sky

With the no. 14 flat, add a bit of Cadmium Yellow + Titanium White + a touch of Peaches 'n Cream to the sky between the mountains to increase the brightness in that area.

3 Highlight Clouds

Switching to a no. 14 flat, highlight the upper cloud edges with Titanium White + Buttermilk. Load only one surface of the brush and paint in a circular motion with the paint held toward the edge of the clouds. Aim for the appearance of the sun shining right down through the clouds.

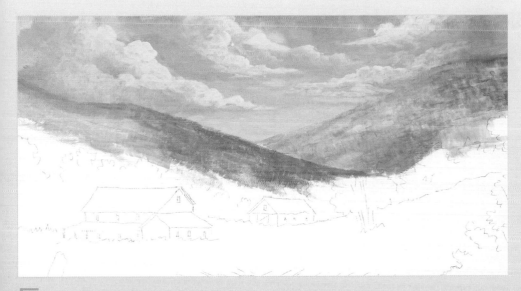

5 Paint Mountains

Using a ¾-inch (19mm) flat wash and Deep Midnight Blue + Titanium White + a bit of Russet, basecoat the mountains. The Russet is just to dull the color a bit, so don't add too much. The back hill should have more white in the mix to keep it distant. Use the flat of the brush, working on the end of the bristles and making short, patting, downward strokes. You want a bit of choppiness in the texture.

It's best to layer the paint to achieve color variation. Occasionally pick up a bit of Black Forest Green for a greener look. Notice that I painted out the top of the middle tree and extended all the way to the edge of the canvas at the top of the the right mountain. Avoid painting right down to the trees on the left mountain. If the mountains look too dark, layer on a bit of Titanium White.

6 Pat in Fog

With the same brush, pat in the hazy fog above the trees next to the mountains, particularly on the left. Use Deep Midnight Blue + Titanium White, and actually paint out the trees.

7 Highlight Mountains

Highlight the top of the left mountain with short patting strokes of Hauser Light Green + Cadmium Yellow + a touch of Buttermilk. Go with the slope of the hill and let the color fade out as you work down the face of the hill. Add further highlights of Peaches 'n Cream. A bit of this color should also be applied to the back hill.

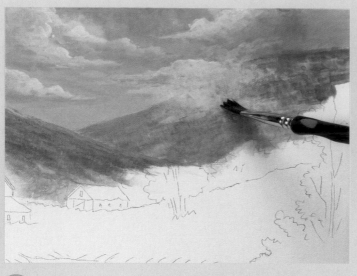

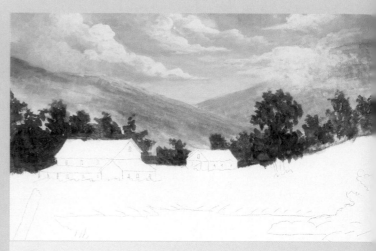

8 Add a Cloud

Painting with a circular motion, add a cloud over the right mountain with Buttermilk.

9 Base the Tree Row

Basecoat the tree row at the bottom of the mountains with a no. 8 flat loaded with Black Forest Green + Russet + touches of Deep Midnight Blue. On the right, avoid painting quite to the bottom of the trees. Instead, let some of the background show.

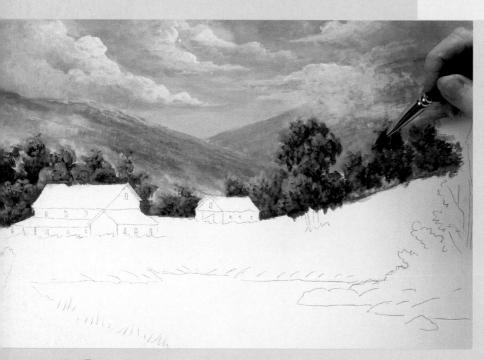

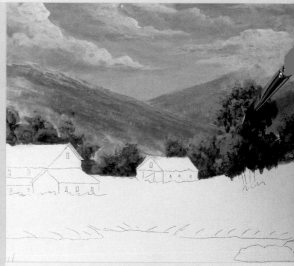

11 Add a Rosy Glow

For the rosy glow on the middle trees, add an extra layer of highlight using Peaches 'n Cream on the right, and Peaches 'n Cream + Cadmium Yellow on the left.

10 Highlight Trees

Using the bottom corner of the no. 14 flat, tap in highlights with Hauser Light Green + Black Forest Green + Buttermilk in varying mixes. Think in terms of clusters, and keep the lightest highlights facing the light source.

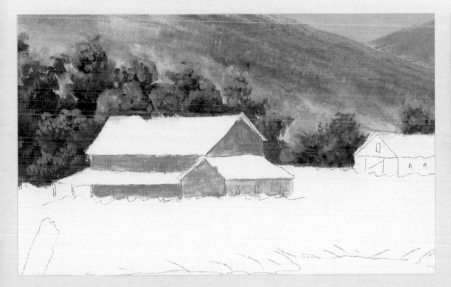

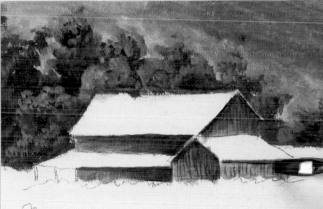

12 Base Barn and Shed

Using a no. 8 flat, base the barn and adjoining shed walls with Buttermilk + Deep Midnight Blue + Russet mixed to a pinkish tan. Paint right over the windows, but keep the open space under the lower roof on the left unpainted.

13 Add Shadows

Add shadows with the same brush and Payne's Grey + a touch of Russet. The darkest areas are under the rooflines and down the right side. Pull the shading on the small shed down to create a bit of streakiness resembling wood grain.

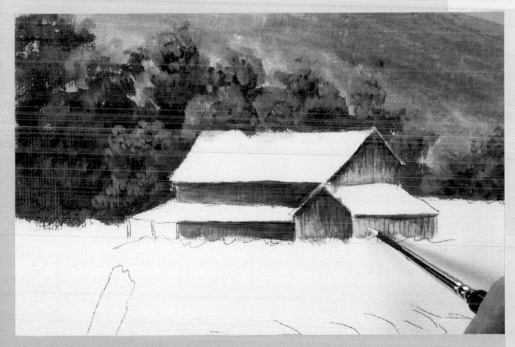

TIP

With acrylic, it's easy to touch up by simply painting over an area with another color. If you lost your tree's dark values under too much green, add them back in. Likewise, you can tuck in more of the blue mountain color to open up the foliage.

14 Add Highlights

Add streaky highlights on the barn gable and the shed sides with Buttermilk and a no. 2 liner. Position this below the shading, and be sure you establish definite light and dark sides of the building.

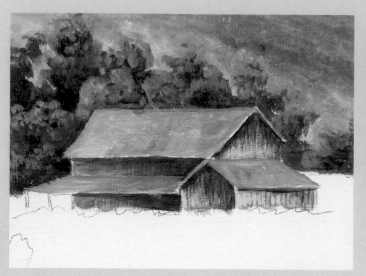

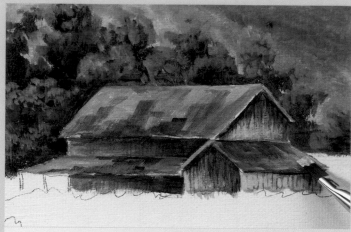

15 Base the Roofs

With a no. 8 flat and Deep Midnight Blue + a touch of Titanium White, base the roofs of the barn and adjoining shed.

16 Add Rust and Highlight

With the no. 8 flat, add areas of rust with a bit of Russet on these tin roofs. Brush with the slant of the roof. Highlight the barn rooftop and the edge of the shed roof with Peaches 'n Cream. Be sure to begin the highlight right at the edge of the barn's rooftop. Then pull it down the slope of the roof.

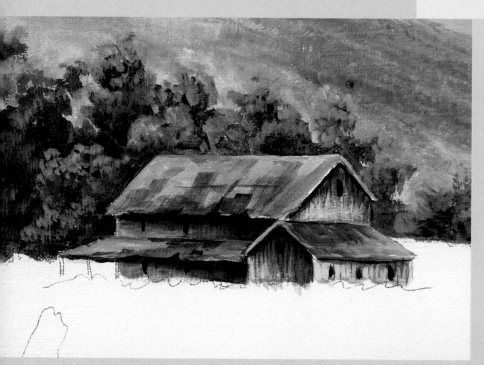

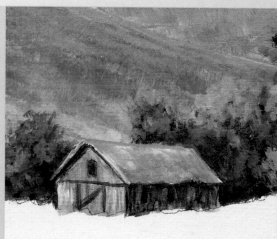

18 Paint Distant Shed

Paint the distant shed, using the same colors and techniques as you did in steps 12 through 17.

17 Add Shadows, Roof Details and Windows

Using the no. 8 flat, deepen the shadows right under the barn and shed roofs with side-loaded Payne's Grey + a bit of Russet. Add some roof cracks and maybe a streak or two on the roof. Switch to a no. 2 liner and block in the windows.

60

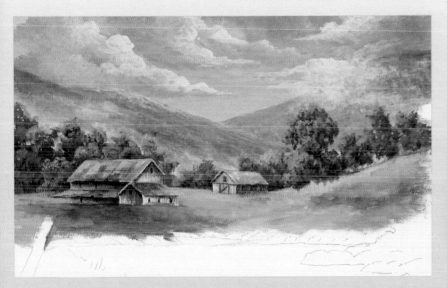

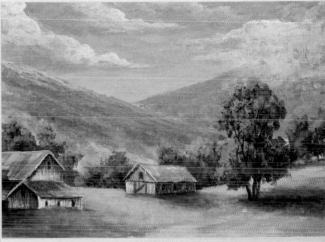

19 Base Grass

Base the grass with Black Forest Green + Cadmium Yellow + Buttermilk + a speck of Russet, varying the proportions. Start with a no. 8 flat, painting around the buildings. As you move away from the buildings, you can move up to a no. 14 flat. Work with short, choppy vertical strokes. As you get to the left area around the barn and in the shadow area in front of the middle tree, use more Russet + Black Forest Green. In lighter areas use more Buttermilk + Cadmium Yellow. Layer color on top of color to achieve light and dark areas. You can leave the rocky area around the shoreline unpainted for now.

20 Highlight, Deepen Shadows and Add Trunks and Limbs

Using a no. 14 flat, highlight the grass with more Cadmium Yellow + Buttermilk. Brush in deeper shadows as needed with thinned Black Forest Green + Russet. Switch to a no. 2 liner and run trunks and limbs on the middle tree with Russet + Deep Midnight Blue. Run the limbs in and out of the leaf clusters. Do the same with the distant trees on the right.

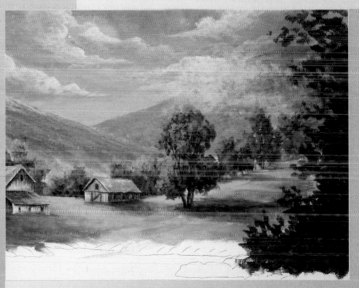

21 Paint Supporting Posts

Using the no. 2 liner and Payne's Grey, pull in supporting posts for the barn's lower roof shed.

22 Add Foliage on Right

Tap in the tree and shrubbery at the right with the bottom corner of the no. 14 flat and Black Forest Green + Russet.

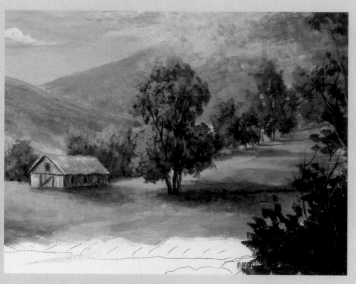

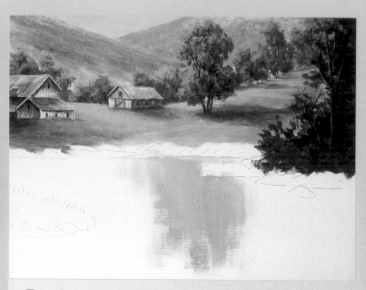

23 Base and Highlight Trunks and Limbs

Pull in the trunks and limbs with a no. 2 liner and Payne's Grey + Russet. Highlight with Peaches 'n Cream.

24 Highlight Water

Paint the water highlight area with a no. 14 flat and Peaches 'n Cream + Titanium White. Stroke downward.

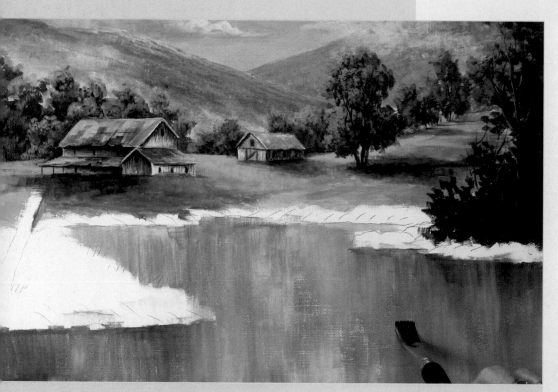

TIP

To keep the highlight on the water especially bright, I painted it first. If I had highlighted over the dark basecoat, the highlight would have been dulled.

25 Base Water

Paint the rest of the water with Deep Midnight Blue + Titanium White. Use downward, overlapping strokes. Stretch the color out thin as you go over the edges of the Peaches 'n Cream. Make the shadow areas under the banks darker.

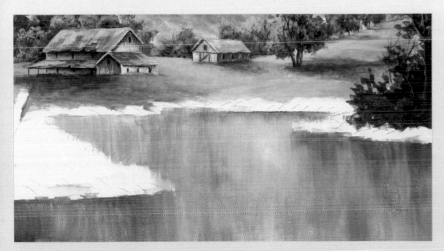

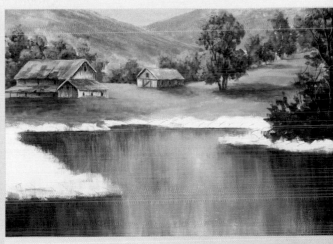

26 Smooth Highlight Edges

Pick up some Peaches 'n Cream + Titanium White and work the edges of the highlight area again, overlapping into the darker water. Remember to use downward strokes. You can work back and forth between the light and dark colors as often as necessary until you get an effect you like with no harsh lines between colors. Be sure you have a little blue mix beneath the bank above the highlight.

27 Deepen Shading

Deepen the shading under the banks with thin Black Forest Green + Russet on a no. 14 flat, stroking downward. Apply several thin layers. If you have abrupt lines between colors, either thin the paint or work some lighter basecoat color over the shading edges.

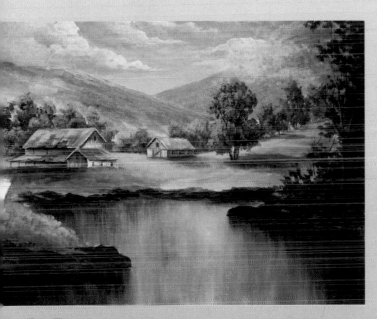

29 Highlight Rocks

Using a no. 14 flat, highlight the rocks with a bit of Peaches 'n Cream + Russet + Buttermilk in varying combinations and proportions of mix. Start the highlight a bit above the dark basecoat to avoid a dark line at the top. Stroke a little of the highlight color on the side of the rock to show the shape, but be sure you don't lose all of the lower dark areas of the rocks.

28 Block in Foreground Grass and Banks

Block in the remaining grass area on the bottom left with a no. 14 flat and Black Forest Green + Hauser Light Green + Russet. Add some Buttermilk highlights. Block in the banks with Russet + a little Payne's Grey in two coats. Let the colors vary to help suggest rocks. If the rocks seem to be floating on the water, pull a bit of the rock color down into the water for a reflection and quickly brush lightly across.

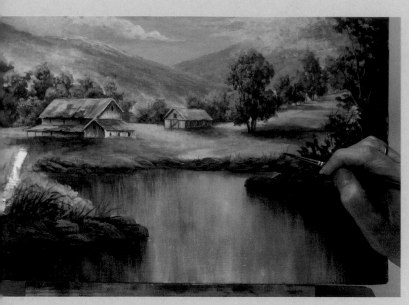

30 Work With Grass Around Rocks

With the same brush and appropriate grass colors (Hauser Light Green, Black Forest Green, etc.), break up the top of the rock line in a few places so the transition from rocks to grass is less stark. Use a no. 14 flat. Pull grasses on the bottom left with a no. 2 liner and Black Forest Green + Russet + Payne's Grey.

31 Add Fence Post and Wire

With the no. 8 flat, base the fence post with Payne's Grey + Russet. Highlight the right side with Peaches 'n Cream on a no. 2 liner. With thinned Payne's Grey on the liner, paint in the wire around the top of the post.

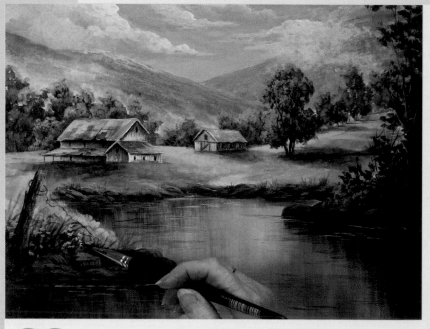

32 Stroke in Water Movement Lines

Using the chisel of the no. 14 flat, very lightly stroke in horizontal movement lines on the water with Peaches 'n Cream and Deep Midnight Blue + Peaches 'n Cream.

33 Dot in Flowers

With a corner of the no. 14 flat, dot in Peaches 'n Cream flowers in the grasses on the lower left and in the shrubbery on the right.

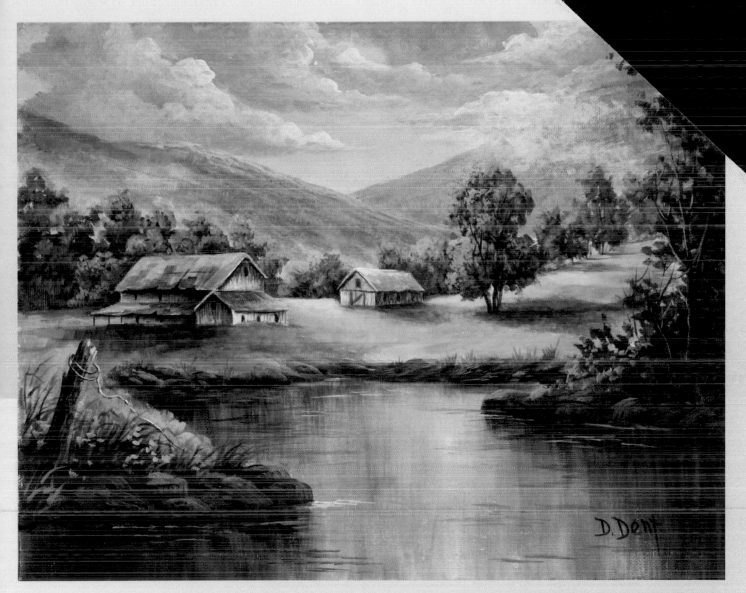

Take a Closer Look

Look at the painting in the last step to the left. I'm very happy with it, especially the way the light fills the sky between the mountains and then follows through to highlight the mountain sides, the treetops and the water. I want to brighten the grass around the distant shed with more Cadmium Yellow and Buttermilk. I also think the extreme right of the shed's lower roof needs to be darkened. Finally, I feel that a bit more highlight on top of the rock jutting into the water on the right will help pull it away from the water behind it. These adjustments have been made to the painting above.

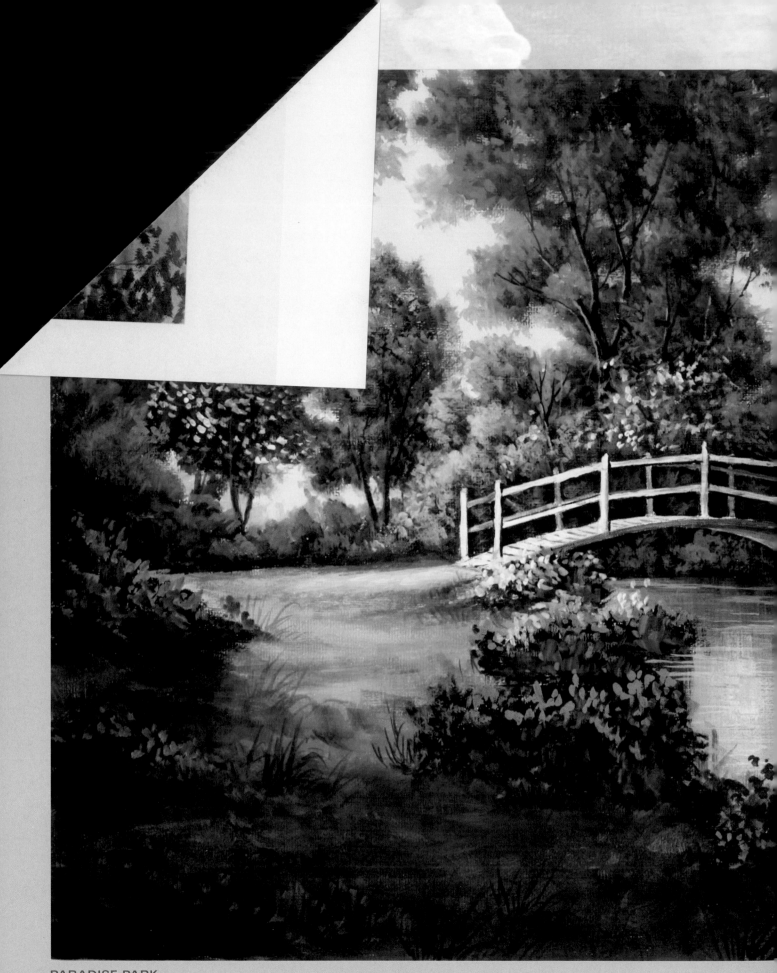

PARADISE PARK

66

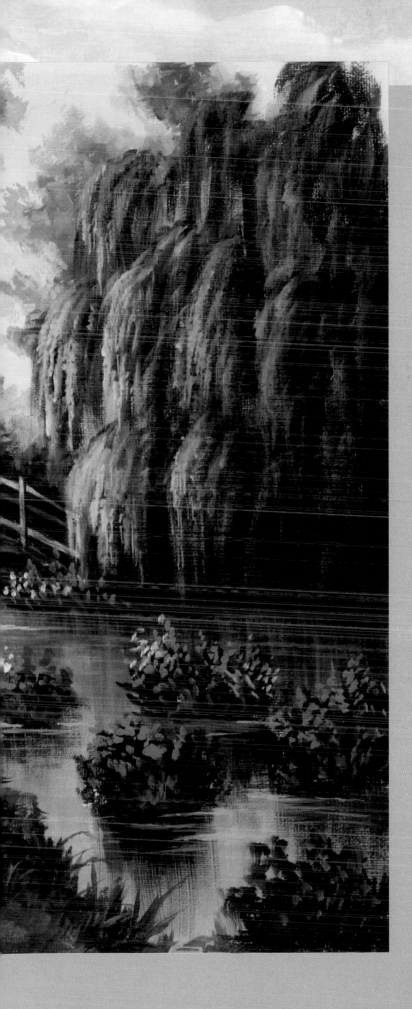

paradise park

midmorning light from the left

There's no doubt that this painting's light source is on the left. Highlighting the end of the bridge and the surrounding area while keeping enough dark for contrast establishes a nice center of interest. We just can't keep from looking at a strong light value against a good dark value, and that contrast can't help but create a focal point.

However, a painting should not have more than one center of interest. You may have other areas of light and dark, but there should be one area that stands out from the others. This isn't always easy. Ideally, the center of interest will be somewhere off-center rather than right in the middle of the painting. Also, the center of interest should not be at the edge of the canvas, which would lead the viewer's eyes out of the painting. When painting, be sure to plan ahead!

67

Alizarin Crimson

Baby Blue

Black Forest Green

Black Green

Payne's Grey

Royal Fuchsia

Royal Purple

Russet

All paints are DecoArt Americana Acrylics

PATTERN

This pattern may be hand-traced or photocopied for personal use only.
Enlarge at 200 percent. The enlarge again at 106 percent to bring up to full size.

Buttermilk

Golden Straw

Hauser Light Green

Orchid

Titanium White

Williamsburg Blue

Yellow Light

materials

Surface

Stretched canvas, 12" x 16"
(31 cm x 41cm)

Martin/F. Weber Museum Emerald Brushes

- Nos. 8 & 14 flat, series 6202
- No. 2 liner, series 6206

Other Materials

- White gesso
- 2-inch (51mm) disposable sponge brush
- Tracing paper
- Black graphite paper, tape and stylus, pen or pencil
- Brush basin
- Palette
- Paper towels
- DecoArt Americana Sealer/Finisher

a quick look at lighting and values

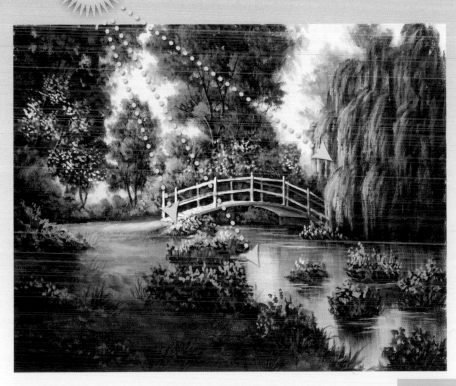

SEASON
Spring

TIME OF DAY
Midmorning

LIGHT SOURCE
From the sun, above the
canvas on the left

This black-and-white photo of
"Paradise Park" allows you to
see the relative dark and light
values in the painting without
the distraction of color.

As the diagram indicates,
the light comes from outside
the canvas on the top left.

1 Paint the Sky

Basecoat the canvas with gesso and transfer the pattern (see pages 8-9). Using the corner of a no. 14 flat loaded with Buttermilk + a little Titanium White, paint the sky.

2 Shape Distant Trees

With the bottom corner of the same brush, pat in Baby Blue + a bit of Titanium White to shape the blue trees in the distance.

3 Darken Trees

With the same brush, paint darker areas of the trees with Williamsburg Blue. Soften the edges with Baby Blue and Baby Blue + Titanium White.

4 Paint Distant Field

With the same brush, paint the distant green field behind the trees with Hauser Light Green + Buttermilk + a touch of Yellow Light. This green area should lean to yellow to keep the area bright.

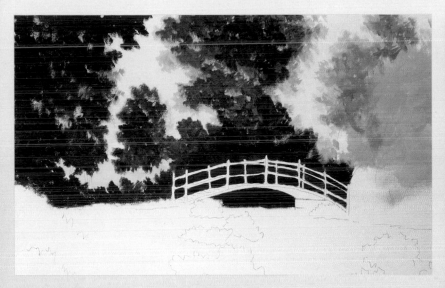

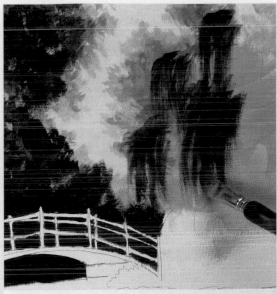

5 Base Large Tree Shapes

With the same brush, base the dark tree shapes on the left and in the middle of the painting with Black Green. Tap in the color and let some of the blue show. Think in terms of leaf clusters. As you approach the bridge, go down to a no. 8 flat and carefully paint around the rails.

6 Begin Basing Willow

For the weeping willow, use the no. 14 flat to pull downward strokes of leaf clusters. Work the brush with a flicking action.

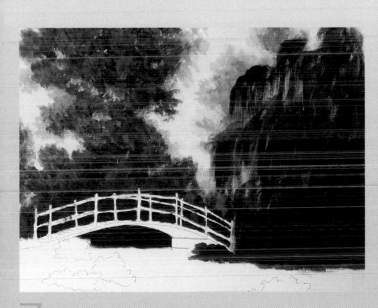

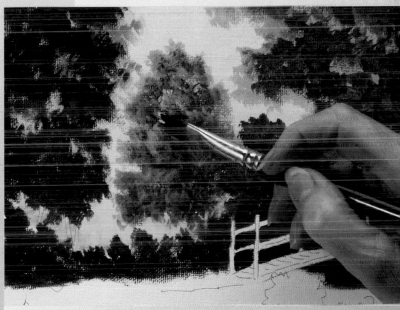

7 Finish Basing Willow

Here you see the basecoat of the willow completed.

8 Begin Light Values on Trees

Now with a no. 14 flat and a light, bright green value of Black Forest Green + Buttermilk, begin to add lighter values to the second tree from the left. Be sure you work in leaf clusters. Tap the color in with the bottom corner of the brush, staying brighter toward the left and extending the highlights beyond the edge of the dark base. Let areas of dark remain.

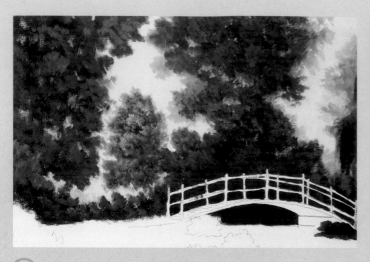

9 Highlight Left and Center Trees

Still using the no. 14 flat, highlight the trees on the left and in the center of the painting with Black Forest Green + Buttermilk. Make the paint heavier and brighter on the left of the clusters, letting the lighter values fade into darker as you move to the center of the tree. Be sure to get some of the color between the bridge rails, under the bridge and on the low bushes between the bridge end and the left tree.

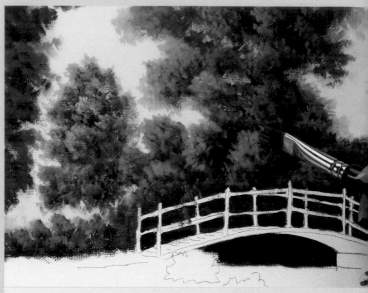

10 Continue Highlighting

On the leaf clusters to the left of the central tree and on the lower bushes, add highlights with Hauser Light Green + Yellow Light.

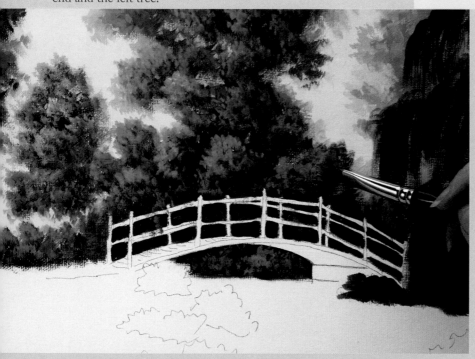

11 Let Highlights Fade

Let the highlights fade out as you go into the darker part of the tree. Add as many layers as necessary to build up the light. Don't forget to highlight under the bridge.

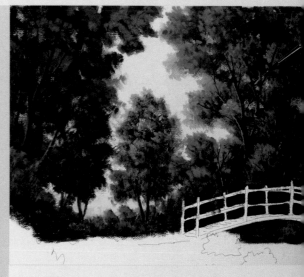

12 Paint Limbs and Trunks

Using a no. 2 liner and thinned Black Green, paint tree limbs going in and out of the foliage on the three trees on the left. Also paint the trunks. Highlight here and there on the left side of the limbs and trunks with Golden Straw.

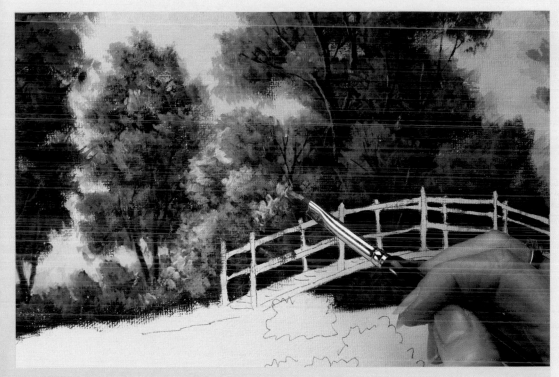

TIP

It the trees look too solid, you can open them up by painting in sky holes. In this case, use either Baby Blue or Buttermilk + Titanium White.

13 Add Lightest Highlights

With Golden Straw + Yellow Light on a no. 8 flat, add the brightest and lightest highlights to the foliage in the area above and to the left of the bridge. Build up brightness with several layers.

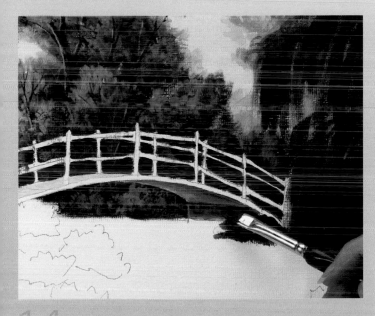

14 Start Lower Bridge Parts

Paint the floor of the bridge with the no. 8 flat and Buttermilk. Paint the bridge underside in Williamsburg Blue. Then shade the right support and the right of the lower arch with Payne's Grey.

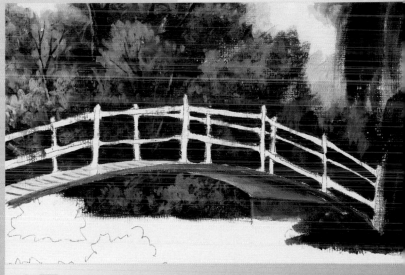

15 Finish Lower Bridge Parts

With a no. 2 liner and Russet + a touch of Buttermilk, paint the edge of the bridge floor. Fade into a lighter value as you approach the foreground. Add board lines with Russet + a touch of Payne's Grey on the floor of the bridge.

73

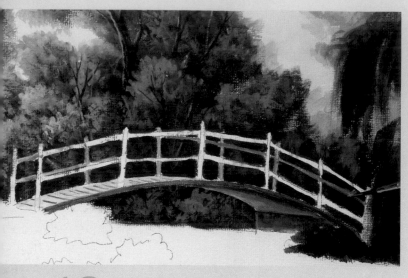

16 Paint Back Posts and Rails

With the no. 2 liner, paint the back posts and rails of the bridge with Buttermilk + a touch of Williamsburg Blue. The value should be light enough to show up against the trees.

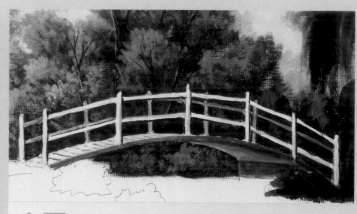

17 Complete Posts and Rails

Paint the front posts and rails with Titanium White. Shade to the right of the posts and in touches along the rails with Baby Blue. Shade on the right of the foreground posts with a line of Black Green. You can also clean up edges around the posts with this color. You may want to add a few streaks of Titanium White to the floor of the bridge on top of the Buttermilk for additional light.

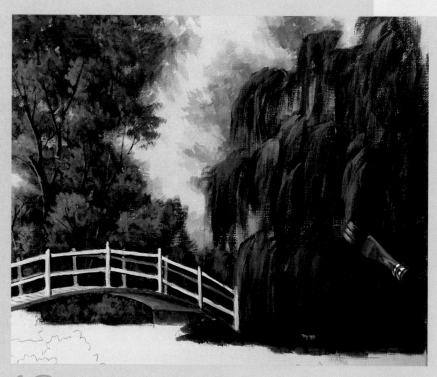

18 Begin Willow Highlights

For weeping willow highlights, load one flat side only of a no. 14 flat with Black Forest Green + Buttermilk. With the paint on the left, start at the top of a leaf cluster and flick down.

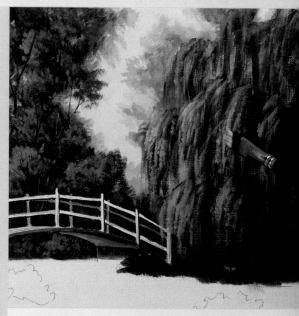

19 Brighten Willow Highlights

Add further highlights on the left of the willow with Hauser Light Green + Yellow Light + a touch of Buttermilk. Keep the brush load light, and apply the paint with a light touch. Apply several layers.

20 Base Water

Base the water with Baby Blue using a no. 14 flat. Let dry.

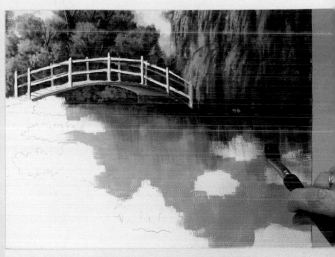

21 Pull Down Distant Reflections

Pull reflections down into the distant water with layers of thinned Black Green. Use the flat side of a no. 14 flat. If necessary, pick up Baby Blue and blend into the reflections. Also pull down Hauser Light Green for lighter reflections.

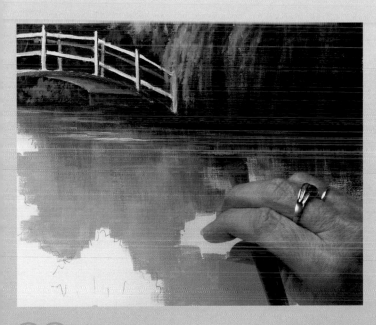

22 Add Movement Lines

Using the chisel of the no. 14 flat, add Baby Blue and Baby Blue + Titanium White movement lines in the water reflection area.

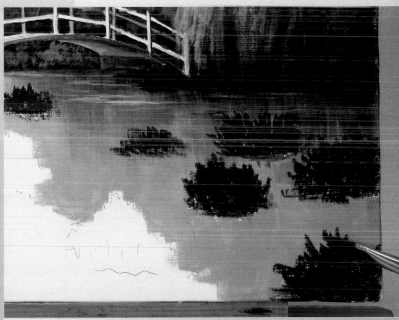

23 Block in Flower Clusters on Water

Block in flower clusters on the water with Black Green on a no. 14 flat. Make the edges uneven at the top and flatter on the bottom where they sit on the water. Use the side of the bottom corner of the brush to tap in the color. You may paint in more or fewer flowers clusters than are shown in the pattern.

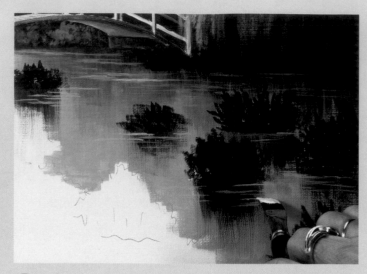

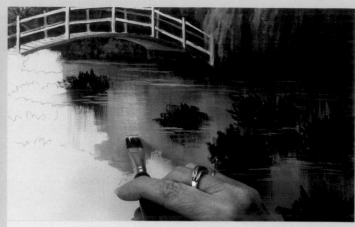

24 Pull Reflections and Add Movement Lines

With the same brush and thinned Black Green, pull down reflections from the flower clusters. Add horizontal movement lines with a touch of Baby Blue and a touch of Titanium White or a mix of the two.

25 Make Water Shine and Add Movement Lines

With the same brush, add a few downward strokes of Titanium White to create shine in the water. You may need to layer in the color a couple of times to create the brightness needed. Add ever-so-light movement lines with the chisel edge of the brush while the paint is still damp.

TIP

Reflections on water make objects appear to be sitting in the water rather than floating above it.

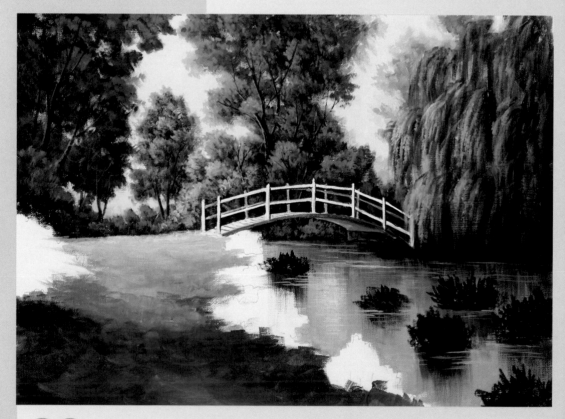

26 Brush in Grass in Varying Values

Brush in the grass with a no. 14 flat, using Hauser Light Green + Buttermilk and starting at the top and working down. As you descend into the middle grass area, add Black Forest Green to the mix, varying colors and values. As you approach the near foreground, darken further with Black Green.

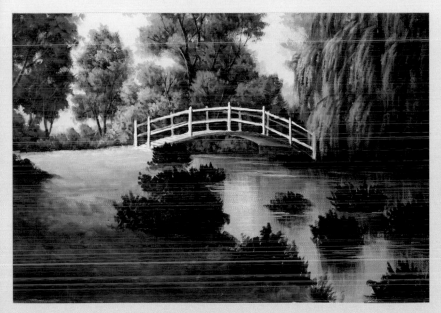

27 Block in Flower Clusters on Grass

Block in flower clusters on the ground with Black Green on a no. 14 flat. Use the same technique as you did in step 23.

28 Add Lighter Leaves to All Clusters

With the bottom corner of the no. 14 flat, add Black Forest Green and Hauser Light Green leaves to the flower clusters, staying toward the bottom and sides of the clusters, and being sure not to entirely cover the dark green.

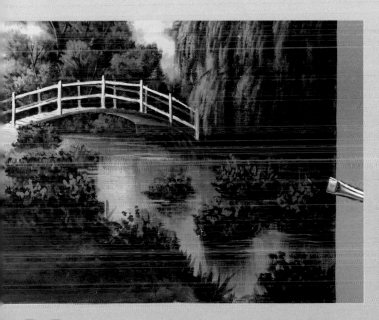

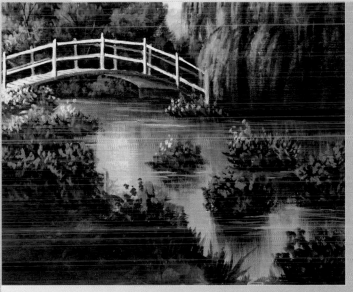

29 Start Tapping in Flowers

Tap in flowers with the bottom corner of the no. 14 or no. 8 flat. Working one color at a time, start with Orchid, Royal Purple, Royal Fuchsia, Alizarin Crimson and any mixture of these colors. Note that the flowers start toward the top of the green clusters and rise above these dark green leafy bases. The brighter pinks are toward the top.

30 Continue with Lighter Flowers

Next come the lighter flowers. Note that these are largely around the bridge, which is the center of interest. The bright, light colors help draw attention to this area. Use Yellow Light, Titanium White and touches of Golden Straw.

77

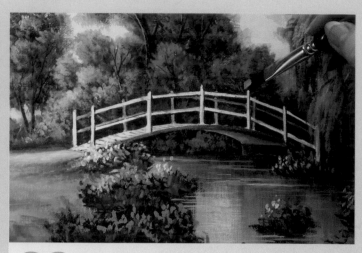

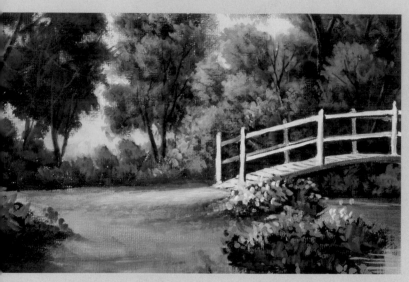

31 Work Contrasts for Lightest Grassy Area

Using the chisel edge of the no. 14 flat, pull out the light grass leading up to the bridge, using Yellow Light + Titanium White. To keep this area very bright, make sure it's surrounded by darker values. You may need to add more Black Green to the background bushes or Black Forest Green + Hauser Light Green to the grass closest to this light area. Let this area dry and then highlight the brightest spot with more Yellow Light if needed.

32 Add Flowers Behind Bridge

With the corner of the no. 14 flat, tap in flowers behind the bridge with Orchid and Fuchsia. These should be rather smudgy—no sharp edges because they are in the distance.

TIP

Establishing light against dark is always important, but particularly so when you're working for dramatic lighting effects.

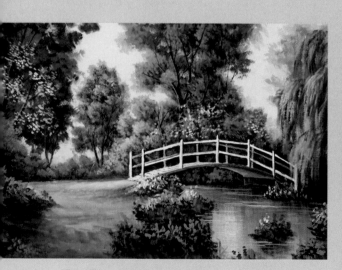

33 Tap in Dogwood Blossoms

Again with the corner of the no. 14 flat, tap in Titanium White dogwood blossoms in front of some of the dark trees.

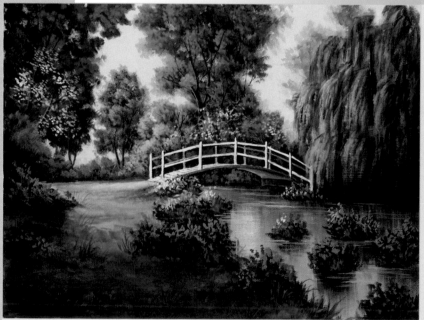

34 Pull Tall Grasses

Pull up tall grasses in the foreground with a no. 2 liner and thinned Black Green or Black Forest Green.

Take a Closer Look

Look at the painting in the last step to the left. I like the way the focal area is highlighted. In particular, I notice the yellow flowers at the end of the bridge, the darker foreground (which throws the eye back to the lighter area) and the bright bridge rails, on the left.

I do feel, however, that the bridge needs to be shaded down a little with thinned Payne's Grey on the right. I also want to soften the leafy edge of the left tree where it meets the sky. I can do this by working in a bit of Baby Blue and Black Forest Green. On the willow, I also want to brighten the willow highlights on the far left with touches of Hauser Light Green + a bit of Yellow Light. These adjustments have been made to the painting above.

GARDEN PATHWAY

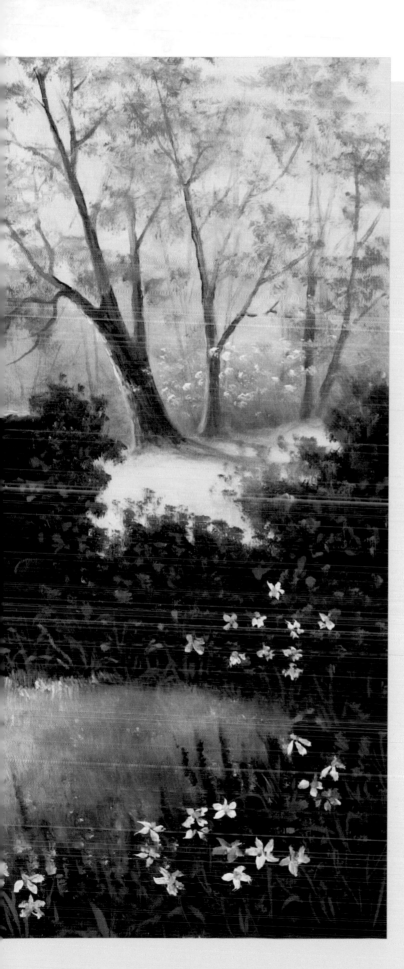

garden pathway

light from the left

I had no reference for this painting—just the desire to paint a scene with lots of flowers. Wouldn't you like to stroll down this little pathway on a beautiful spring day to see what lies around the bend?

Although the light sky is in the center of the painting, it is not the light source. Notice the light striking the top and left sides of the rock pillars. From this, and the fact that we know that the shadows on the road and from the trees are falling in the opposite direction of the light source, we can readily determine the sun is somewhere on the left.

This painting offers a good lesson in color values. It's important for the distant trees to be lighter in value than the closer bushes and foliage, because lighter values appear to recede and darker values appear closer. Also, the dark rock wall and pillars add nice contrast to the light values in the distance.

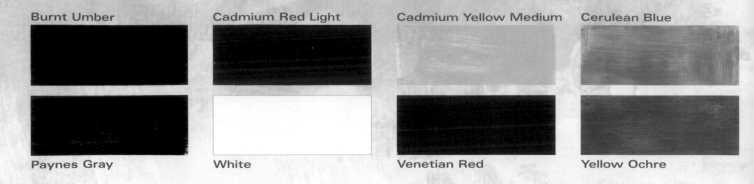

Burnt Umber

Cadmium Red Light

Cadmium Yellow Medium

Cerulean Blue

Paynes Gray

White

Venetian Red

Yellow Ochre

All paints are Martin/F. Weber Professional Permelba Artists Oil Color

D. Dent

PATTERN

This pattern may be hand-traced or photocopied for personal use only.
Enlarge at 200 percent. Then enlarge again at 106 percent to bring up to full size.

Cobalt Blue	Cobalt Turquoise	Cobalt Violet	French Ultramarine Blue

materials

Surface

Stretched Canvas, 12" x 16"
(31 cm x 41cm)

Dorothy Dent Brushes

- Small background
 (no. 6 bristle flat)
- Detail flat (no. 8 sable flat)
- Foliage fan (no. 4 bristle fan)
- Liner (no. 1 sable liner)
- Filbert (no. 4 sable filbert)

Other Materials

- White gesso
- 2-inch (51mm) disposable sponge brush
- Tracing paper
- Black graphite paper, tape and stylus, pen or pencil
- Odorless turpentine (for rinsing and cleaning brushes) and rinse basin
- Palette
- Martin/F. Weber Liquiglaze
- Martin/F. Weber Res-n-gel
- Paper Towels
- Damar Varnish

a quick look at lighting and values

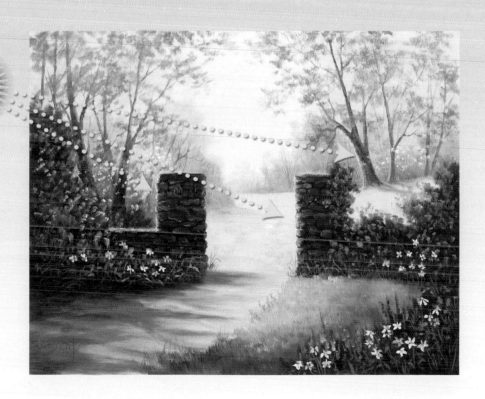

SEASON
Spring

TIME OF DAY
Midmorning or
midafternoon

LIGHT SOURCE
From the sun, at the
upper left of the canvas

This black-and-white photo of
"Garden Pathway" allows you
to see the relative dark and
light values in the painting
without the distraction of color.

As the diagram indicates,
the light comes from outside
the canvas, on the left.

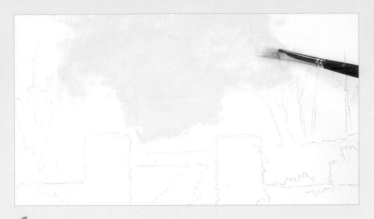

1 Prepare for Painting and Start the Sky

If the canvas is rough, add one or two coats of white gesso. Trace the pattern onto the canvas with black graphite paper. (See pages 8-9). As you paint with oils, add a bit of Liquiglaze to your colors to help them spread easily. Add a little Res-n-gel to the entire pile of white so it will dry faster.

Using the no. 6 bristle flat, brush White + Cadmium Yellow Medium in the center of the sky and over a bit to the left.

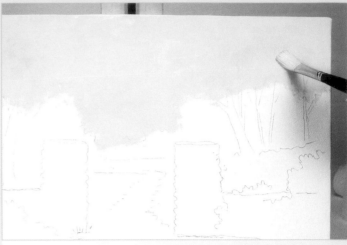

2 Fill Out Sky

Add White + Cobalt Blue + Cadmium Yellow Medium (light green) to the sky edges. Vary the colors, using more Cobalt Blue on the far sides. The texture should be blotchy to resemble distant foliage.

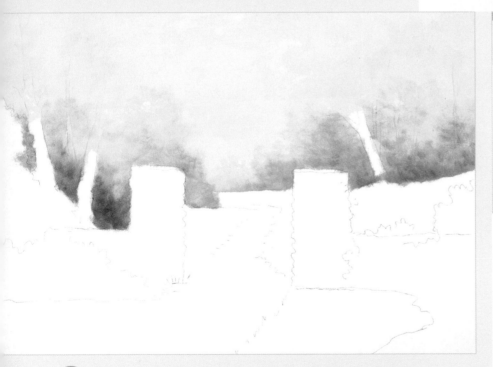

3 Paint the Distant Foliage

With the same brush, paint the distant tree foliage at the bottom of the sky with a dark value of Cobalt Blue + Cadmium Yellow Medium + French Ultramarine Blue + White. Add more French Ultramarine Blue to the mix to darken the values at the sides and bottom.

4 Add Light Trunks and Limbs

Paint the lighter trunks and limbs with a no. 1 sable liner and background tree colors. Thin the paint with Liquiglaze or turpentine, if necessary.

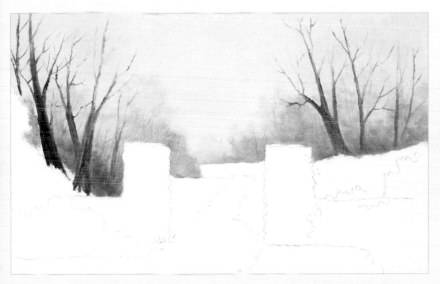

5 Paint Darker Trunks and Limbs

Using a no. 4 sable filbert, paint the darker trunks and limbs with French Ultramarine Blue + Cadmium Red Light, thinning the paint as needed.

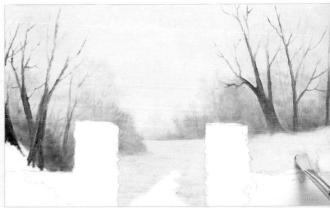

6 Base Distant Grass

Using the no. 6 bristle flat, paint the distant grass behind the posts and on the right with White + Cadmium Yellow Medium + Cerulean Blue (light green). Vary the color, adding French Ultramarine Blue + Cadmium Red Light in the shadows and using more Cadmium Yellow Medium + White in the lighter areas. Paint right over the more distant portion of the path.

7 Add Tree Highlight and Shadow

Add a highlight to the large tree near the right post with a no. 1 sable liner and White + Cadmium Yellow Medium. With the no. 8 sable flat and French Ultramarine Blue + Cadmium Red Light, paint the tree shadows on the right.

8 Base Bushes on Left

Using the no. 6 bristle flat, base the dark bushes above the left wall with French Ultramarine Blue + Burnt Umber. The color should be very dark, but leaning toward the blue.

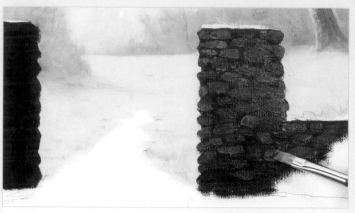

9 Base Posts

Using the no. 8 sable flat, base the posts with French Ultramarine Blue + Burnt Umber, leaving a thin line at the top where you will later add the highlight. Because the posts are stone, the sides should be uneven.

10 Shape the Stones

Shape individual stones with Venetian Red + Yellow Ochre + White. Vary the colors and leave dark mortar lines between the stones. Avoid creating even layers of stone, because these field-stones are irregularly shaped. Starting with the stones in the middle of the post can help.

TIP

When painting stone posts or other stone objects, be sure to paint the stones all the way to the edge of the object.

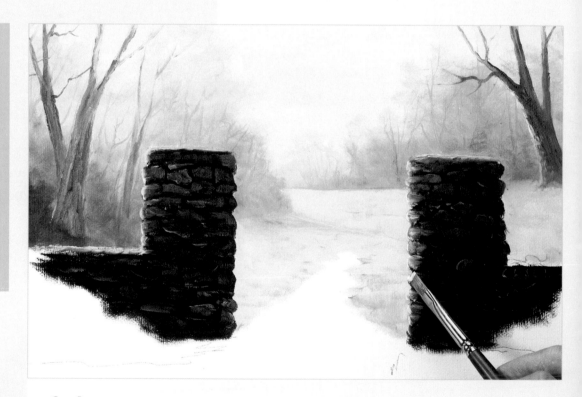

11 Highlight Posts

Still using the no. 8 sable flat, highlight the top and left side of the posts and the top of the left wall with White + Yellow Ochre + Cadmium Yellow Medium. Load one surface of the brush and then flip the brush so the paint side faces up. The highlight lies a bit beyond the edge of the stone and then runs into the stone. Soften the highlight next to the stone.

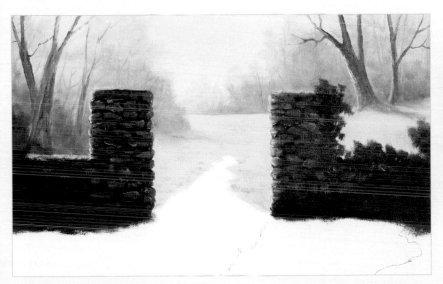

12 Enhance Stone Texture

Using the same brush, add Cobalt Violet + White on the right side of the left post. Load one brush surface and turn the paint side toward the right. Add a few touches of Cobalt Turquoise + White to both posts.

13 Base Bushes

Using the no. 6 bristle flat, base the bushes beneath the walls and in the right foreground. Use Burnt Umber + French Ultramarine Blue in varying colors, once in a while adding a bit of Paynes Gray. Don't forget the foliage running up the right post.

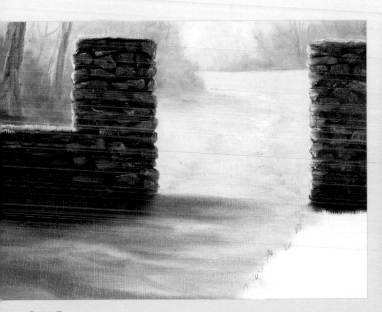

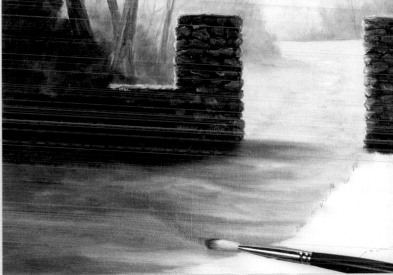

14 Base Path

Using the same brush, paint the path in White + Yellow Ochre + Venetian Red, making it lighter in the distance and adding more Venetian Red in the foreground. Start with the most distant part of the path, making sure it curves behind the distant foliage. Pat the edges to soften, perhaps adding a bit of green. As you move in front of the wall, if your brush happens to hit some of the dark bush just pull it into the path for shading.

15 Shade Path

Using the same brush, shade the path with French Ultramarine Blue + Cobalt Violet, varying the color. Start next to the wall and foreground foliage and pull into the path.

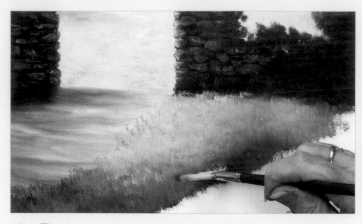

16 Base Foreground Grass

Paint the grass in the foreground, using the fan brush grass technique (see page 17) with a no. 4 bristle fan. Use Cobalt Blue + French Ultramarine Blue + Cadmium Yellow Medium + White, starting with a very light green near the post and picking up more blue as you work to the right and downward.

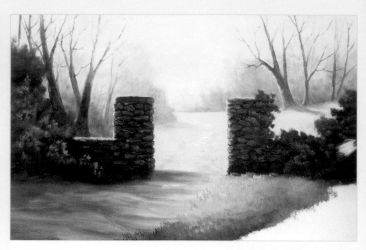

17 Add Color and Values to Bushes

Using the corner of the fan brush, add medium to light greens to the bushes with Cobalt Turquoise + Cadmium Yellow Medium + a touch of White + a touch of French Ultramarine Blue. You don't have to add too many touches, since the bushes are to be covered with flowers.

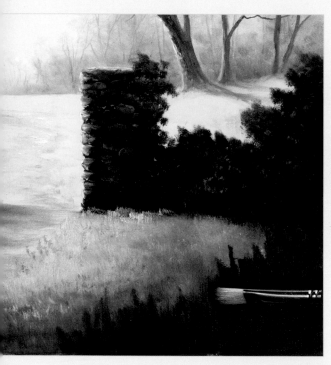

19 Tap in Blue Flowers

Tap in the blue flowers with the corner of the no. 6 bristle flat and French Ultramarine Blue + Cobalt Violet + White. Vary the colors, keeping them brighter towards the sunny area.

18 Base Foreground Foliage

Using the no. 6 bristle flat, base the foliage in the lower right foreground. Use Burnt Umber + French Ultramarine Blue in varying proportions, occasionally adding a bit of Paynes Gray. Since this foliage contains tall flowers, let some long stalks rise into the grass.

20 Tap in Pink Flowers

With the same brush, tap in pink flowers with Cadmium Red Light + White.

21 Tap in Yellow Flowers

Tap in yellow flowers with the same brush and Yellow Ochre, sometimes adding a bit of Cadmium Red Light.

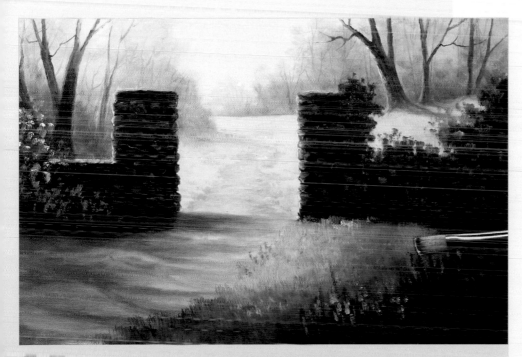

22 Tap in Tall Blue Flowers

Tap the tall blue flowers in front with the side of the same brush and French Ultramarine Blue + Cobalt Violet + White, varying the colors.

TIP

Since flowers often grow at the end of a branch or stem, when you tap in flowers over background foliage, be sure you place some beyond the edges of the foliage.

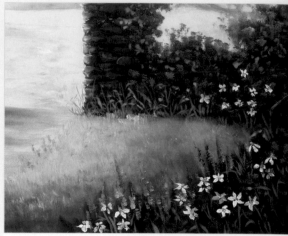

23 Paint White Flowers

Paint the small white flowers with a no. 1 sable liner. Starting each petal at the outside and pressing lightly, pull in to the center. Add touches of French Ultramarine Blue + White. Dot in centers with Cadmium Yellow Medium + Yellow Ochre.

24 Fill in Foliage

Still using the liner, pull in flower leaves and grasses with varying greens thinned with turpentine. Use mixes of French Ultramarine Blue, Cobalt Turquoise, Cadmium Yellow Medium and White. Be sure some of the foliage bends or curves. You may also want to fill in some leaves in the bushes.

25 Paint Leaf Clusters in Distant Trees

Using the corner of a no. 6 bristle flat, tap in the distant tree foliage with French Ultramarine Blue + Cadmium Yellow Medium + a touch of White, varying the colors. Paint leaf clusters, not paying too much attention to the limbs. Some leaves can be painted where no limbs appear.

26 Tap in Dogwood Blossoms

With the same brush, tap in White dogwood blossoms, using the brush corner.

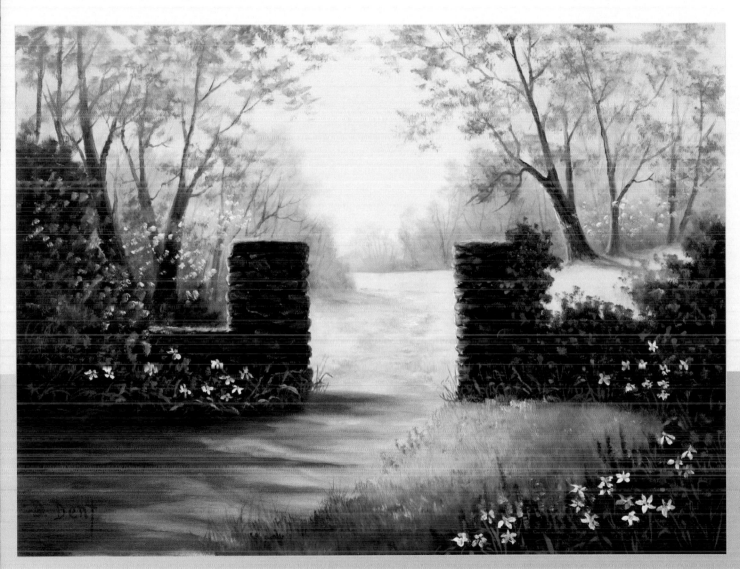

Take a Closer Look

Look at the painting in the last step to the left. The light in the distance is coming across well with the brightness in the sky reflected in the grass. I also like the contrast of the dark posts against the sunny areas. The flowers are working nicely, and I like the purple path shadows against the complementary gold path.

Even so, I want to strengthen the path shadows and also extend the foliage in front of the left wall. I also want to add more branches to the distant trees seen above the left post and the large tree behind the right post. Finally, I would like a few more grasses reaching over the path in the foreground. These adjustments have been made to the painting above.

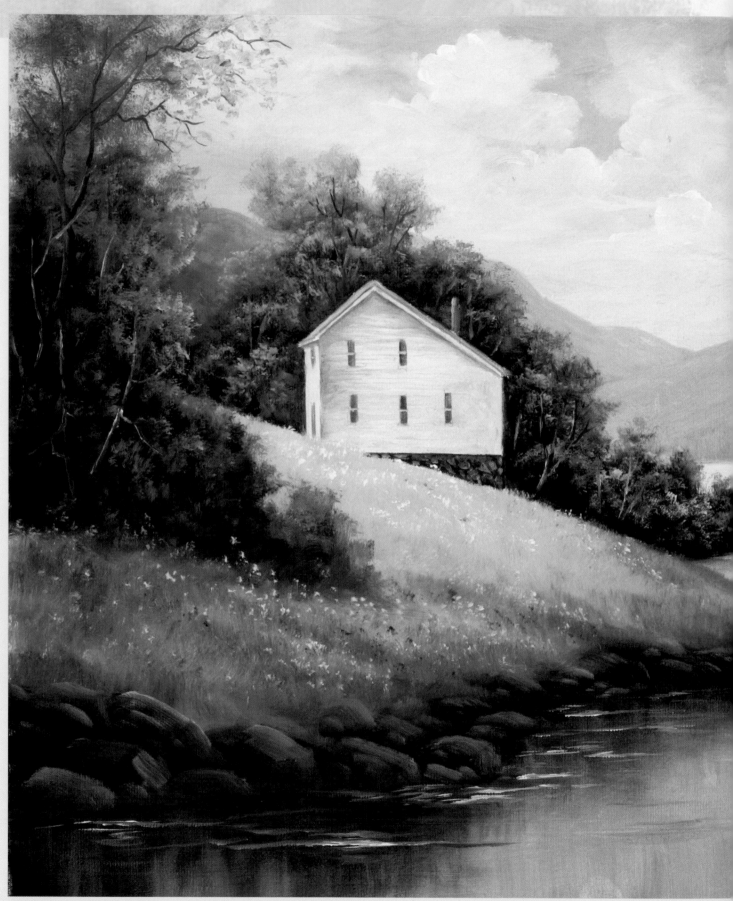

WARM SUMMER DAYS

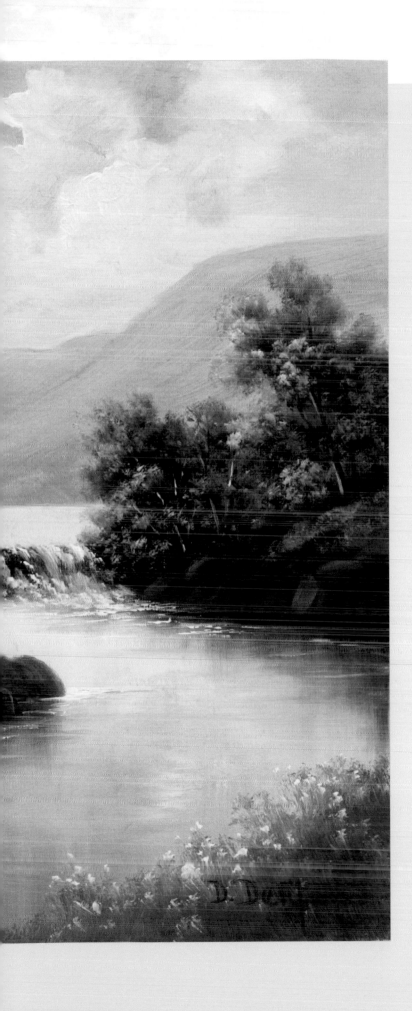

warm summer days

strong light from the left

Looking at this painting, I can almost feel the warmth of a late summer afternoon. The sun is beginning to drop, and the strong light slanting from the left across the landscape sets off the left side of the house as well as the hilltop below the house. Surrounding dark foliage accentuates the light.

Besides being a fine study in light, this painting also offers a good lesson in painting standard landscape elements—grass, water, trees and clouds.

Burnt Sienna **Burnt Umber** **Cadmium Red Light** **Cadmium Yellow Medium**

Yellow Ochre

All paints are Martin/F. Weber Professional Permelba Artists Oil Color

D. Dent

PATTERN

This pattern may be hand-traced or photocopied for personal use only.
Enlarge at 200 percent. Then enlarge again at 107 percent to bring up to full size.

Cobalt Blue

Cobalt Turquoise

French Ultramarine Blue

White

materials

Surface

Stretched canvas, 12" x 16"
(31 cm x 41cm)

Dorothy Dent Brushes

- Small background
 (no. 6 bristle flat)
- Detail flat (no. 8 sable flat)
- Foliage fan (no. 4 bristle fan)
- Liner (no. 1 sable liner)
- Filbert (no. 4 sable filbert)

Other Materials

- White gesso
- 2-inch (51mm) disposable sponge brush
- Tracing paper
- Black graphite paper, tape and stylus, pen or pencil
- Odorless turpentine (for rinsing and cleaning brushes)
 and rinse basin
- Palette
- Martin/F. Weber Liquiglaze
- Martin/F. Weber Res-n-gel
- Paper Towels
- Damar Varnish

a quick look at lighting and values

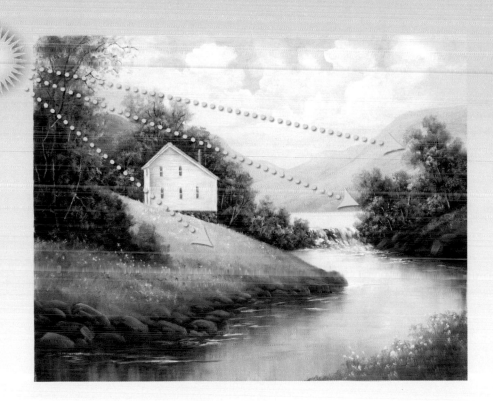

SEASON
Summer

TIME OF DAY
Late Afternoon

LIGHT SOURCE
From the sun, to the left
of the canvas

This black-and-white photo of
"Warm Summer Days" allows
you to see the relative dark and
light values in the painting
without the distraction of color.

As the diagram indicates,
the light comes from the left.

1 Prepare for Painting and Start the Sky

If the canvas is rough, add one or two coats of white gesso. Trace the pattern onto the canvas with black graphite paper. (See pages 8-9.) As you paint with oils, add a bit of Liquiglaze to your colors to help them spread easily. Add a little Res-n-gel to the entire pile of White so it will dry faster.

Using the no. 6 bristle flat, paint the upper sky French Ultramarine Blue + White, leaving white canvas for the clouds. Let some clouds go over the upper canvas edge. Paint the lower sky in a light value of White + a bit of Cobalt Turquoise.

2 Add Cloud Color

Using the same brush and White + a touch of Cadmium Red Light for a soft pink, paint in the clouds. Run the cloud edges over the blue a bit, picking up some of the color to blend and create a puffy look. If you're losing too much blue sky, just brush it back in.

3 Highlight Cloud Edges

Highlight some cloud edges in the middle area with White, using heavier paint than you did previously. Remember that the sunlight is slanting in from the left.

4 Base and Highlight Mountains

Still using the no. 6 bristle flat, base the mountains in French Ultramarine Blue + White. Make the value a bit darker than the sky, so the mountains appear in front of the sky. Let the color value vary, and follow the general slope of the ground. Clean the brush and add highlights of Cadmium Red Light + White (soft pink).

5 Tap in Hint of Trees

With the same brush, tap in soft green trees above the water with French Ultramarine Blue + a touch of Cadmium Yellow Medium + a touch of White. Keep these trees subtle.

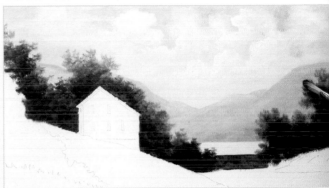

6 Paint Distant Water and Base Dam

With the same brush, paint the distant water with a very light Cobalt Turquoise + White. Then base the dam with French Ultramarine Blue + Burnt Umber. The dam basecoat should be dark, but don't go heavy with the paint.

7 Base Mid Range Tree Foliage

Still using the same brush, base in the trees and foliage behind the house, toward the dam and on the right bank. Use French Ultramarine Blue + Burnt Sienna + occasional touches of Burnt Umber. The lower foliage is darker—a dark blue black. Run the foliage on the left above the mountain and into the clouds. In this area, use the bottom corner of the brush, holding the bristles vertically and patting for a soft feathery look.

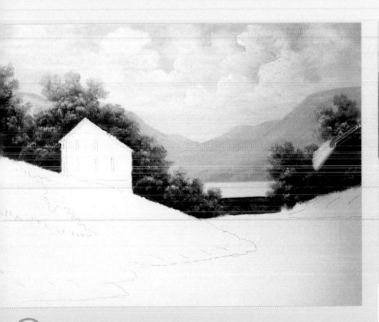

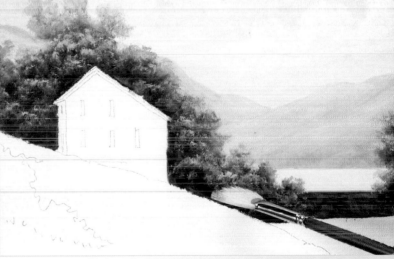

8 Highlight Leaf Clusters

You're now ready to add tree highlights with the fan brush foliage technique (see page 17). Use a no. 4 bristle fan and Cobalt Turquoise + French Ultramarine Blue + Cadmium Yellow Medium + White in varying proportions. Remember to hold the brush perpendicular to the painting surface with the paint on the top side of the bristles. Since the sun is shining from the left, the lightest, most plentiful highlights are to the left of the leaf clusters. Highlighting helps define these clusters.

9 Shade Foliage

Add touches of French Ultramarine Blue + a bit of White to the foliage on the left and right of the dam. Think of the blues as being in the shaded areas of foliage.

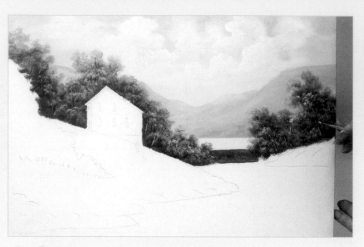

10 Add Trunks and Limbs

Add trunks and limbs with a no. 1 sable liner and thinned Burnt Umber + French Ultramarine Blue. Thread the limbs in and out of the foliage. Highlight the left side of the trunks and limbs with unthinned Yellow Ochre + White. You may want to add a few more limbs just using this highlight color.

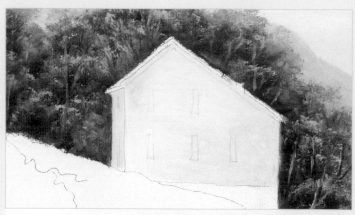

11 Base House

Base the left, sunny side of the house with a no. 4 sable filbert and White + Cadmium Yellow Medium + a touch of Cadmium Red Light (soft light orange). Base the shaded side of the house with White + French Ultramarine Blue + a tiny touch of Burnt Umber (very light blue gray). You want the look of a white house with a brightly lit side and a shaded side.

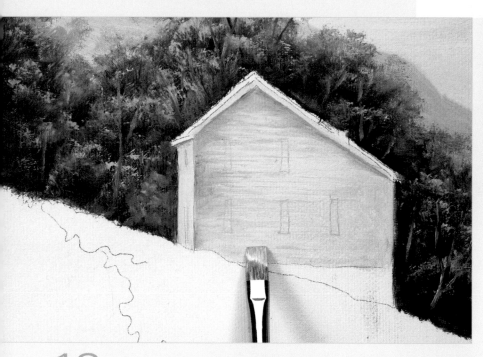

12 Shade Along Roofline and Paint Siding Lines

Using the no. 6 bristle flat, add a line of slightly darker White + French Ultramarine Blue + Burnt Umber under the roofline (fascial boards), at the top of the wall and against the left corner. Draw some of this color from the left partly across the face of the house. Using the chisel edge of the brush, paint in light siding lines with the same mix.

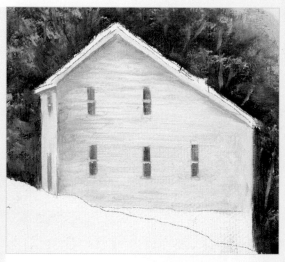

13 Paint Windows and Door

Paint windows and the door with French Ultramarine Blue + Burnt Umber + a touch of White. Hold the chisel edge of the no. 6 bristle flat against the left edge of the openings and draw it across. The window and door on the sunny side of the house are slightly lighter. With the no. 1 sable liner and White, paint a dividing line through the middle of the windows.

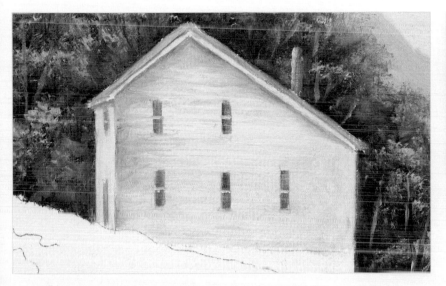

14 Detail Roof and Base Chimney

Using the no. 4 sable filbert and White + a bit of Cadmium Yellow Medium + Cadmium Red Light, paint the edge of the roof. Also take a bit of French Ultramarine Blue + Burnt Umber and paint a line between the roof and the fascial board. Base the chimney in Burnt Sienna + White, making the mix a touch lighter on the left.

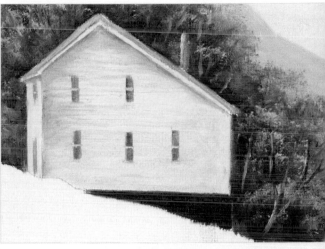

15 Base Foundation

Using the no. 8 sable flat, base the foundation in Burnt Umber + French Ultramarine Blue.

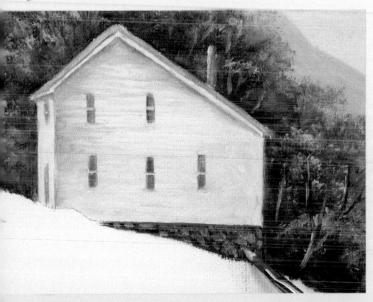

16 Pat in Rock Shapes

Return to the no. 4 sable filbert and pat in small irregular rock shapes with White + Burnt Sienna. Be sure to leave some dark base showing for mortar.

17 Paint Grass on Far Bank

Paint the grass on the far bank with a no. 4 bristle fan, using the fan brush grass technique (see page 17). Mix various proportions of White + Cadmium Yellow Medium + Cobalt Blue + French Ultramarine Blue. The grass reflects more sunlight at the top of the hill, so start with more yellow and white in the mix and then add more blues as you work down the hill. A bit of Liquiglaze helps keep the paint loose. Remember to hold the brush perpendicular to the surface and make short downward strokes.

18 Base Left Foreground Foliage

Using a no. 6 bristle flat and French Ultramarine Blue + a touch of Burnt Umber, base the foliage in the left foreground.

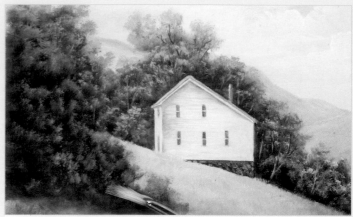

19 Continue Foliage

Add to the foliage with a no. 4 bristle fan and White + Cobalt Blue + French Ultramarine Blue + a bit of Cadmium Yellow Medium. You don't want these highlights to be too yellow green, but rather a blue green tone. You want good contrast against the sunny grass.

20 Paint Trunks and Limbs

Using the no. 1 sable liner and thinned Burnt Umber + French Ultramarine Blue, paint the trunks and limbs. Highlight with Yellow Ochre + White.

21 Pull Down Water Under the Banks

Using the no. 6 bristle flat and French Ultramarine Blue + Burnt Umber, paint the water under the banks. Pull the color downward.

22 Add Tree Reflections

Clean the brush and pick up various greens from the trees (White + Cobalt Turquoise + French Ultramarine Blue + Cadmium Yellow Medium) for reflections in the water. Stroke these greens downward. Begin beneath the dark, catching and blending into the bottom of the dark.

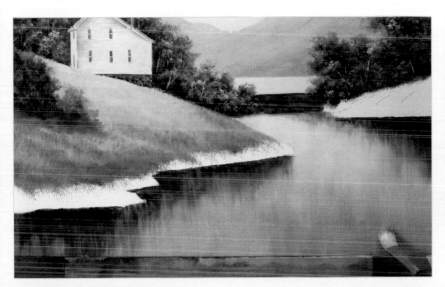

23 Fill in the Water

With a clean brush, start at the dam and fill in the water, beginning with White + Cobalt Turquoise. As you work downward, gradually shift to White + French Ultramarine Blue for darker values. Add a bit of Liquiglaze to your paint for ease in blending. Leave an area unpainted for the pink or pull the paint out quite thin in that area.

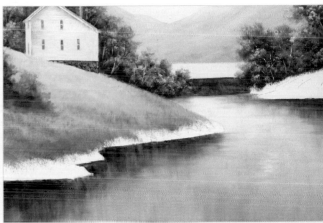

24 Make the Water Shine

Add the spot of pink shining water with White + Cadmium Red Light, brushing the color in with downward strokes and overlapping the surrounding colors. Then add horizontal movement lines by skimming the brush lightly across the water, slightly distorting the downward strokes.

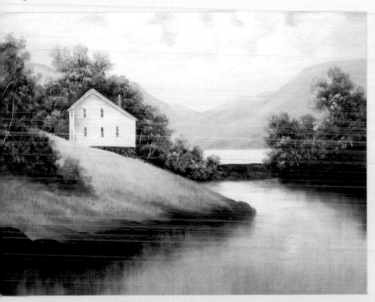

25 Base the Rocky Banks

Still using the no. 6 bristle flat, mix Burnt Umber + French Ultramarine Blue and base in the rocks. If the bank doesn't quite seem to sit in the water, pull the rock color down into the water. Then lightly skim across.

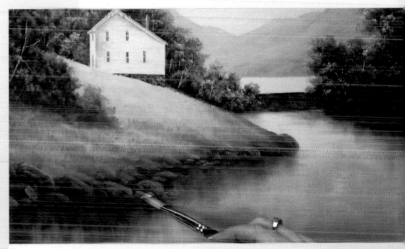

26 Shape Rocks and Fill in Grass

With the same brush, shape the rocks with highlights, but don't make them too bright. Start with French Ultramarine Blue + White on one flat surface of the brush. With the paint side upward, paint with the corner of the brush along the top of the rocks, sometimes pulling down the side. You can also add bits of Yellow Ochre + White and Burnt Sienna + White. Be careful not to lose all of the dark on the sides of the rocks. Add some grass in the crevices between the rocks. Use the same colors you used for the grass directly behind the rocks (see step 17).

27 Pull Water Over the Dam

Load White + French Ultramarine Blue on the corner of the no. 4 bristle fan. Flip the brush over so the paint is on top and pull the water over the dam using the corner of the brush.

28 Add Highlights and Spray

Add White highlights and spray with the corner of the fan brush. Flick and bounce in the color.

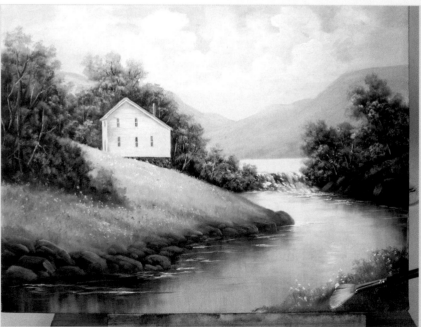

29 Add Movement Lines

With the no. 8 sable flat and White, add movement lines around the rocks, the bank and at the bottom of the waterfall. Add some French Ultramarine Blue to the White for movement lines in the shadow areas of the foreground.

30 Paint Remaining Grassy Bank, Flick in Flowers

Paint the lower right grassy corner as you did the grassy hill in step 17. In this case, the brighter area is nearest the water. Scatter flowers over the grassy areas. Use the no. 4 bristle fan loaded with various colors—White, French Ultramarine Blue + White, Cadmium Yellow Medium and Yellow Ochre. To avoid blocks of color, flick on the flowers with a few corner bristles. If you get a larger block, just paint it over with grass. Note that the white flowers are in the sunniest areas and the blue flowers are in the darkest.

Take a Closer Look

Look at the painting in the last step to the left. I'm extremely happy with this painting. I like the way the sunlight pours in from the left, lighting up the side of the house and the top of the grassy hill and then following through into the water until it reaches the area shaded by the right bank. I also feel the soft mountains add good depth and perspective.

I do notice that the composition could be improved by bringing the foliage of the foreground tree right up to the left corner of the painting. I also want to add some light blue greens on the right of the midsection of this tree. This will push away some of the dark foliage and help separate the large foreground tree from the trees behind the house. These adjustments have been made to the painting above.

D. Dent

peaceful winter night

central moonlight

Painting night scenes with the moon as the light source is a fun change from sunlit daytime scenes. A night with a bright full moon and snow on the ground reflecting the light can almost seem like day.

Since the moon is in the center of this painting, highlights sometimes appear on the left and sometimes on the right. Always paint them on the side that faces the moon. Small lights from the windows also shed their glow on the snow directly beneath them. This glow lends a welcoming look to the little houses.

Burnt Umber

Cadmium Orange

Cadmium Red Light

Cadmium Yellow Medium

White

All paints are Martin/F. Weber Professional Permelba Artists Oil Color

D. Dent

PATTERN

This pattern may be hand-traced or photocopied for personal use only.
Enlarge at 200 percent to bring up to full size.

Cobalt Blue

Dioxazine Purple

Naples Yellow

Paynes Gray

materials

Surface

Stretched canvas, 11" x 14"
(28cm x 36cm)

Dorothy Dent Brushes

- Small background
 (no. 6 bristle flat)
- Detail flat (no. 8 sable flat)
- Foliage fan (no. 4 bristle fan)
- Liner (no. 1 sable liner)
- Filbert (no. 4 sable filbert)

Other Materials

- White gesso
- 2-inch (51mm) disposable sponge brush
- Tracing paper
- Black graphite paper, tape and stylus, pen or pencil
- Odorless turpentine (for rinsing and cleaning brushes) and rinse basin
- Palette
- Martin/F. Weber Liquiglaze
- Martin/F. Weber Res-n-gel
- Paper Towels
- Damar Varnish

a quick look at lighting and values

SEASON
Winter

TIME OF DAY
Late Evening or
Early Night

LIGHT SOURCE
Moon

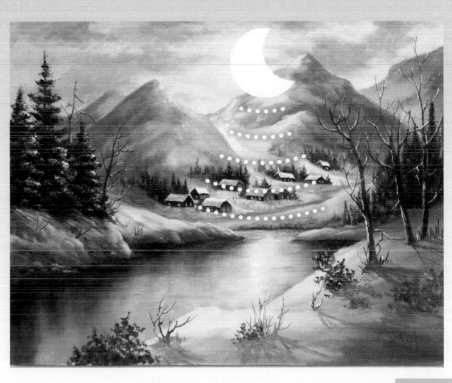

This black-and-white photo of "Peaceful Winter Night" allows you to see the relative dark and light values in the painting without the distraction of color.

As the diagram indicates, the light emanates primarily from the moon. Although the moon doesn't cast rays of light as the sun does, the moonglow does reflect on objects below it. Light from the windows also casts a glow on the ground beneath them.

1 Prepare for Painting and Base Moon

If the canvas is rough, add one or two coats of white gesso. Trace the pattern onto the canvas with black graphite paper. (See pages 8-9). As you paint with oils, add a bit of Liquiglaze to your colors to help them spread easily. Add a little Res-n-gel to the entire pile of White so it will dry faster.

Erase all but the faintest tracing line of the moon so it won't show through the paint. Using a no. 8 sable flat and White + a speck of Naples Yellow + a speck of Cadmium Orange, base the moon. Brush in shadows with a light value of White + a bit of Paynes Gray. If the tracing line still shows, let the paint dry and add another layer.

2 Make the Moon Glow

Using the same brush and White + Naples Yellow, paint the glow around the moon, extending about ½" (13mm) or so beyond the moon's perimeter.

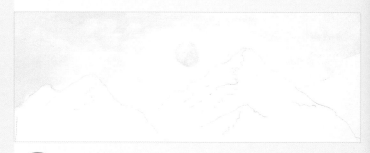

3 Base the Sky

Using a no. 6 bristle flat and a soft light gray value of White + Paynes Gray, base the sky. Let the paint go sparse as you approach the moon haze so you can blend the edges of the two colors. This is easier if the brush has more white than gray.

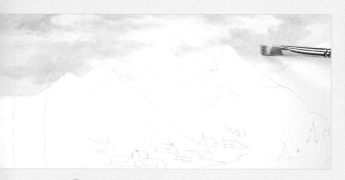

4 Add Clouds

With the same brush and White + Paynes Gray + a touch of Cadmium Red Light, add clouds that are somewhat darker than the sky.

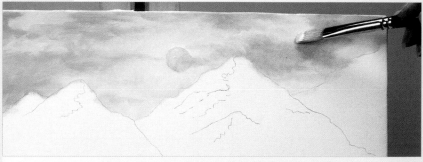

5 Highlight Clouds

On two or three clouds, add a highlight of White + Naples Yellow. Load one flat side of the brush. Turn the paint side up for highlights on top of the cloud. Turn the paint side down for highlights on the underside of the cloud. (Light is dispersed behind the clouds so you see highlighting on both the tops and bottoms.)

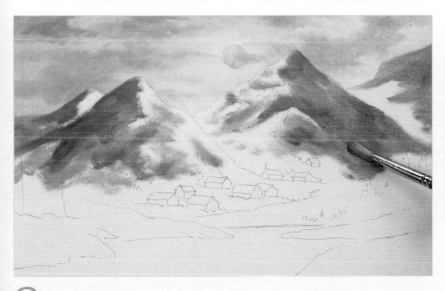

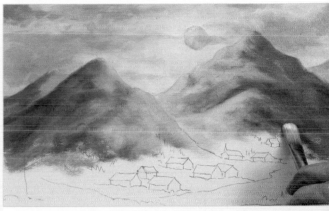

6 Pat in Dark Sides of Mountains

Using the same brush, loosely block in the dark sides of the mountains with Paynes Gray + White. Add a touch of Dioxazine Purple now and then. The moon's glow is the light source, so on the left side of the painting, the dark side is to the left, and on the right side of the painting, the dark side is to the right.

7 Pat in Light Sides and Add Texture

Loosely block in the light sides of the mountain with White + Cobalt Blue, blending into the darks as you go for contours. Once the lighter color is blocked in, go back and add bits of dark with more Paynes Gray to create more crevices and texture. You'll add the lightest highlights later, after the paint has a chance to set up a bit.

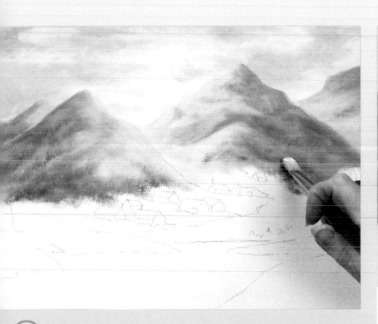

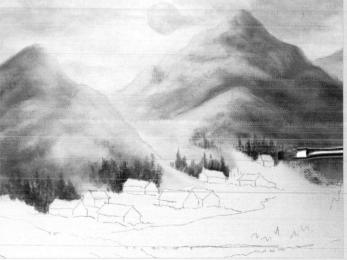

8 Pat in Distant Pines in Mountain Crevice

Still using the no. 6 bristle flat, pat in distant pine trees on the mountain, using Paynes Gray + Cadmium Yellow Medium + White. These are the less distinct trees further from the houses. Use either the corner or flat of the brush and follow the contour of the mountain.

9 Pat in Pines Around Houses

Using the no. 8 sable flat, pat in the more distinct pines close to the houses with a black-green value of Paynes Gray + a touch of Cadmium Yellow Medium. Rather than create a solid block of trees, paint occasional clusters, leaving some snow in between.

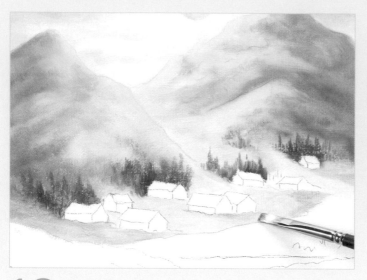

10 Paint Snow Around Buildings

Using the same brush and a light value of Paynes Grey + White + a touch of Cobalt Blue, paint snow around the buildings.

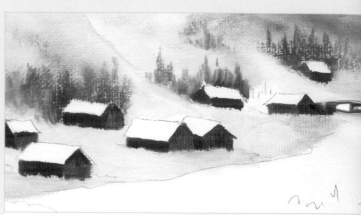

11 Establish the Sides of the Houses

Using the no. 4 sable filbert, paint the buildings. Make the darker sides Burnt Umber and the lighter sides Burnt Umber + a touch of Naples Yellow. Since these houses will eventually have lit windows, the placement of the dark and light sides isn't very important. This distinction is mainly to establish a delineation between the two exposed sides of each house. For tinier areas, you may want to move down to a no. 1 sable liner.

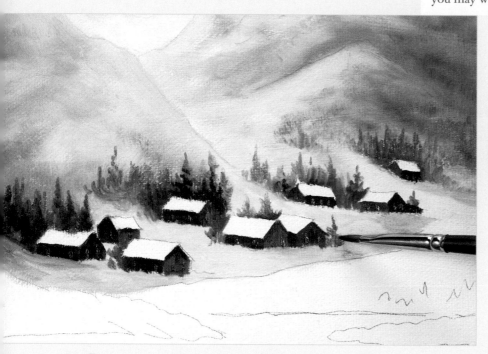

12 Add Pines, Roofs and Lighted Windows

Using the no. 4 sable filbert, fill in a few more pines around the houses with Paynes Grey + the tiniest bit of Cadmium Yellow Medium. Paint roofs with White, shading them with Paynes Grey + White, keeping in mind that they need to contrast with the background. Using the no. 1 sable liner, base the lighted windows with Cadmium Orange.

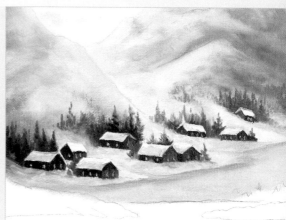

13 Paint Window Glow, Base

Add a touch of Cadmium Yellow Medium in the windows, allowing some Cadmium Orange to continue to show. With the no. 4 sable filbert, paint the window's glow on the snow with White + tiniest bits of Cadmium Orange and Cadmium Yellow Medium. Blend the edges of the glow into the blue-gray snow.

Using the no. 6 bristle flat and White + Paynes Gray, paint the snow bank on the far side of the water. Then with the same colors, but using more Paynes Gray, add the road. You can lay it against the tracing line in front of the houses.

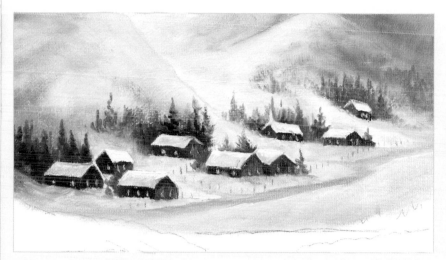

14 Highlight Bank and Paint Fence Posts

Using the no. 8 sable flat, highlight the bank near the edge of the road with White + touches of Cadmium Yellow Medium and Cadmium Orange. Soften the highlight into the bank. With a bit of Paynes Gray on the tip of the no. 1 sable liner, paint the fences between the houses. You need only paint the posts, since the wire between them would not be seen in this light at this distance.

15 Pat in Pines on Right

Using the side of the no. 6 bristle flat, pat in the pines on the right with Paynes Gray + a speck of Cadmium Yellow Medium. Add a bit of White as you paint toward the smaller trees and shrubs on the left of this grouping. It's okay to let little specks of canvas white show, since it will look like snow on the branches.

16 Begin Water

Using the same brush, begin the water with dark values of Paynes Gray + a bit of Burnt Umber beneath the far banks. Stroke straight down. Do not apply much of this value against the farthest bank, since this is where the moon is reflected.

17 Begin Highlight Area of Water

Using the same brush and Paynes Gray + White + a touch of Cobalt Blue, add a lighter value next to the dark water, overlapping the dark and stroking straight down. Leave white canvas in the middle for the brightest moon reflections.

111

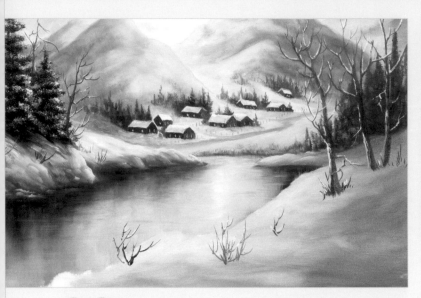

26 Paint Bare Trees on Right Bank

Paint the bare trees on the right bank with thinned Paynes Gray + a little Burnt Umber. Use the no. 4 sable filbert for the trunks and the no. 1 sable liner for the smaller branches. Also paint in the bare scrub and some grasses. Continue with the liner to add White snow and highlights.

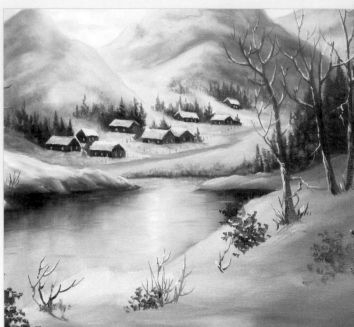

27 Tap in Bush Foliage

Using the bottom corner of a no. 8 sable flat and Paynes Gray + a bit of Burnt Umber, tap in the bush foliage on the right bank.

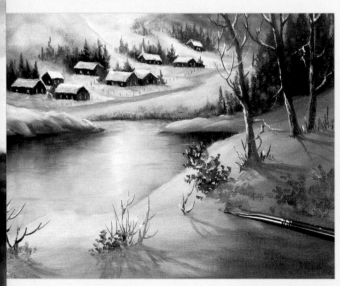

28 Pull Shadows

Using the same brush and Paynes Gray, pull out shadows from the trees, bushes and grasses on the right bank.

29 Enhance Moon Highlighting

Using the no. 8 sable flat and White + Cadmium Orange, paint bright highlights on the mountains. These should be part of the stripe of highlighting from the moon that goes down the mountain, onto the path, into the water and across to the right bank. To build contrast, you may also want to add additional shading in the shadowed areas.

Take Another Look

Look at the painting in the last step to the left. I like the sky and the clouds and the light falling through the middle of the painting. The moon could use some softening with white so it looks less like the sun. I also feel I could add a bit of orange-tinted highlight on the upper left bank to strengthen the light in that area. These adjustments have been made to the painting above.

HILLS OF WEST VIRGINIA

hills of west virginia

strong light from the right

Some years ago when I was on the road for my teaching, I took a photo of this scene—at least, the buildings were there as you see them. I improvised a bit with the foreground. I had originally painted a larger scene with a tiny scarecrow in the garden and a suggestion of two children playing in the yard. (Yes, they were very tiny.) When I decreased painting size, I removed those elements. Don't be afraid to alter or add your special touches to any of my paintings. Rendering a scene your own way is fun.

You can see that the buildings are lighter on the right side, which means the light is coming from the right. As you paint, follow through by adding more light on the foliage and grass where you feel the sun would hit strongly.

I especially like the lighter green grass in front of the house. That lightness helps pull your attention to the house, which is the center of interest.

Burnt Sienna

Burnt Umber

Cadmium Orange

Cadmium Red Light

White

Ultramarine Violet

Venetian Red

All paints are Martin/F. Weber Professional Permelba Artists Oil Color

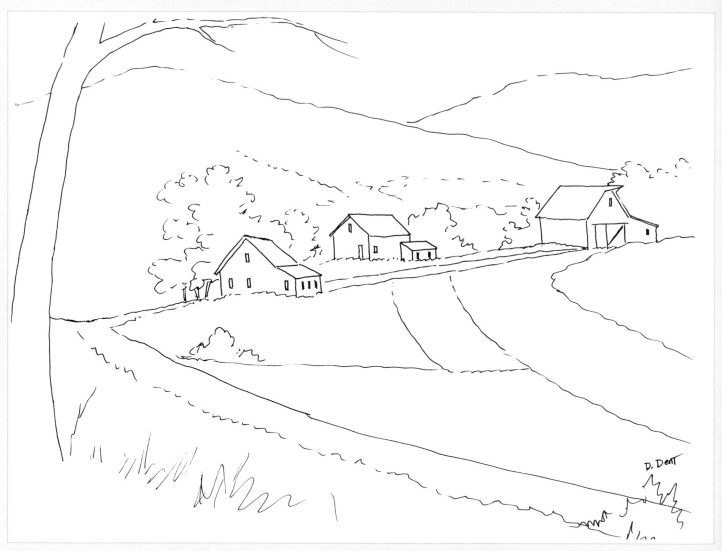

D. Dent

PATTERN

This pattern may be hand-traced or photocopied for personal use only.
Enlarge at 200 percent. Then enlarge again at 111 percent to bring up to full size.

118

 Cadmium Yellow Medium **Cobalt Turquoise** **Indanthrone Blue** **Naples Yellow**

materials

Surface

Stretched canvas, 12" x 16"
(31cm x 41cm)

Dorothy Dent Brushes

- Small background
 (no. 6 bristle flat)
- Detail flat (no. 8 sable flat)
- Foliage fan (no. 4 bristle fan)
- Liner (no. 1 sable liner)
- Filbert (no. 4 sable filbert)

Other Materials

- White gesso
- 2-inch (51mm) disposable sponge brush
- Tracing paper
- Black graphite paper, tape and stylus, pen or pencil
- Odorless turpentine (for rinsing and cleaning brushes) and rinse basin
- Palette
- Martin/F. Weber Liquiglaze
- Martin/F. Weber Res-n-gel
- Paper Towels
- Damar Varnish

a quick look at lighting and values

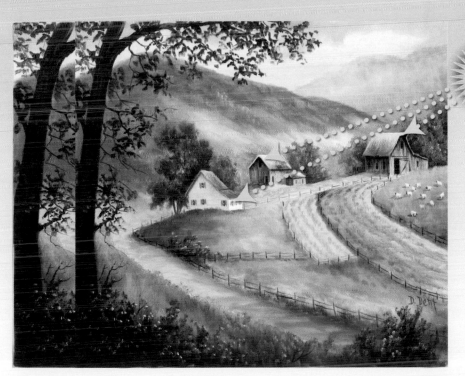

SEASON
Spring

TIME OF DAY
Late afternoon

LIGHT SOURCE
Sun on the right

This black-and-white photo of "Hills of West Virginia " allows you to see the relative dark and light values in the painting without the distraction of color.

As the diagram indicates, the light comes from the right.

1 Prepare for Painting and Begin Sky

If the canvas is rough, add one or two coats of white gesso. Trace the pattern onto the canvas with black graphite paper. (See pages 8-9). As you paint with oils, add a bit of Liquiglaze to your colors to help them spread easily. Add a little Res-n-gel to the entire pile of White so it will dry faster.

Using the no. 6 bristle flat, paint the sky White + Indanthrone Blue, leaving white canvas for the hazy, cloudy areas.

2 Add Clouds

With the same brush, add clouds of White + a touch of Naples Yellow + a speck of Cadmium Orange to create a soft glow. Brush over the edges of the blue to soften the colors together.

3 Paint Distant Hill

Using the same brush, paint the distant hill with short, patting, downward strokes made with the flat of the brush to give the impression of trees and foliage. At the hilltop, use lighter values of White + Indanthrone Blue + Ultramarine Violet. Darken as you move down the hill, and add a touch of Cobalt Turquoise in the center of the hill.

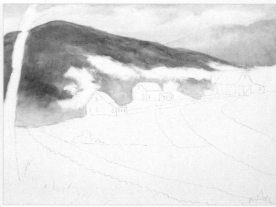

4 Base the Closer Hill

Using the same brush, base in the closer hill with Indanthrone Blue + Naples Yellow + a touch of White. Vary the colors and leave the treeless patches in the center unpainted. Pick up more White + a touch of Cobalt Turquoise for a cool blue behind the buildings at the bottom. Overlap the color above, working for a hazy or foggy look.

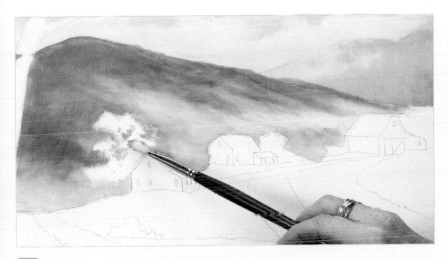

5 Lay In Treeless Areas and Pat in Tree Sky Holes

Using the same brush, lay in the gold treeless areas of the mountain with White + Naples Yellow + a touch of Cadmium Orange, patting into the greens to soften the edges. Pat a bit of the green over the gold to dull it if it looks too bright or harsh. Pat sky holes into the trees behind the house with Indanthrone Blue + Naples Yellow + a touch of White.

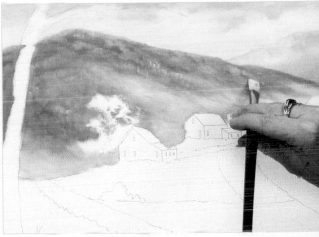

6 Highlight Hill

With the same brush, highlight the hill with White + Cadmium Yellow Medium + a touch of Indanthrone Blue mixed to a light yellow-green. Load only one surface of the brush and pat with short downward strokes, letting some of the darker values show through.

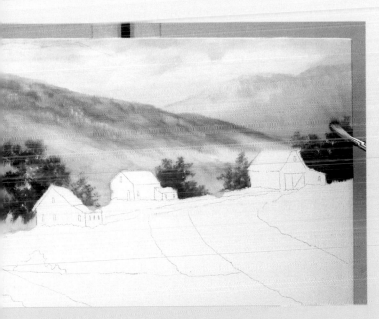

7 Base Midground Trees

Using the corner of the same brush, base in dark values on the trees behind the buildings with Indanthrone Blue + a touch of Cadmium Yellow Medium + a touch of Cadmium Red Light.

8 Highlight Trees and Add Trunks and Limbs

Using the fan brush foliage technique (see page 17), highlight the trees behind the house with Cobalt Turquoise + Cadmium Yellow Medium + White on a no. 6 bristle fan. Lighten the highlight a bit for the trees around the other buildings, adding touches of Naples Yellow and Naples Yellow + Cadmium Orange. With the no. 1 liner, add trunks and a few limbs to the large tree behind the house.

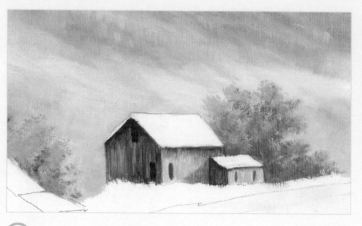

9 Base First Barn and Shed

Using the no. 4 sable filbert, base the dark sides of the centrally placed barn and shed and the dark line beneath the eaves with thinned Burnt Umber. Pull the color down to resemble boards. Paint the lighter sides Burnt Umber + White. Add a layer of Naples Yellow to boost the lightest areas. Add windows and a door with Burnt Umber.

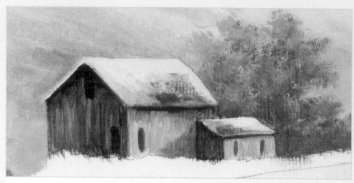

10 Paint Roofs

Using the same brush, paint the bottoms of the roofs White + a touch of Indanthrone Blue. Then paint from the top down with White + Naples Yellow, letting this bright top area blend into the blue bottom. Add touches of Venetian Red for the rusty area at the bottom of the roofs. You may need to build up the green behind the roofs for contrast. To do this, use Indanthrone Blue + White + a speck of Cadmium Yellow Medium.

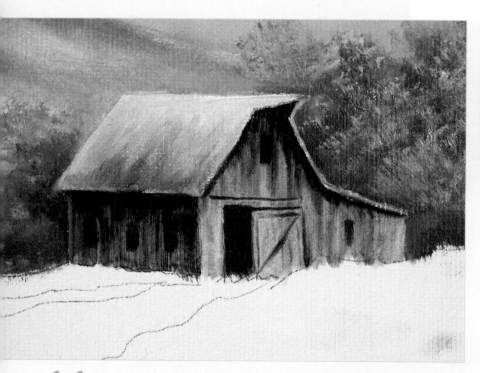

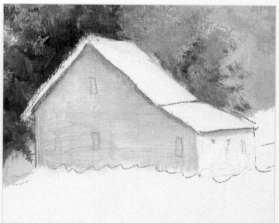

11 Paint Right-hand Barn

Paint the large barn on the right as you painted the buildings in steps 9 and 10.

12 Paint Shaded Side of House

Still using the no. 4 sable filbert, paint the shaded side of the house and the line beneath the eaves with White + a touch of Indanthrone Blue + a touch of Ultramarine Violet. Deepen the shadows beneath the eaves with more blue and violet. Paint the sunlit right wall with White + a touch of Naples Yellow, adding a bit of the blue shading directly beneath the roof.

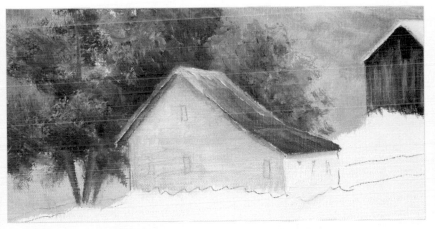

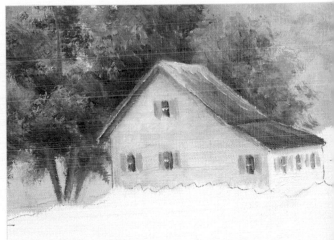

13 Paint House Roof

Paint the bottom, darker areas of the roof with Venetian Red + Burnt Sienna + a touch of Naples Yellow, working from the bottom upward. Then paint the upper, lighter areas of the roof with Naples Yellow + White, working from the top down and blending in the middle with short strokes. If necessary, clean up the edge of the roof with the appropriate tree colors. Use the chisel edge of the brush to lightly place a line of light Indanthrone Blue where the slant of the roof changes angle.

14 Add Windows and Shutters

Still using the no. 4 sable filbert, paint the windows Indanthrone Blue + Cadmium Red Light. Add shutters of Indanthrone Blue + Cobalt Turquoise + a touch of Cadmium Yellow Medium. Paint the pane line with the no. 1 sable liner and White + Indanthrone Blue.

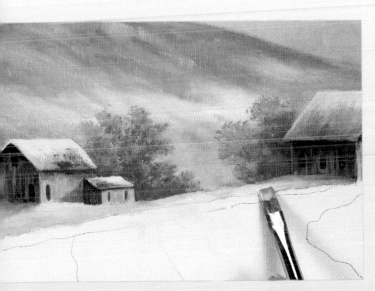

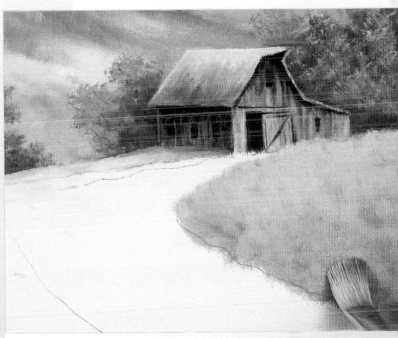

15 Stroke in Grass Around Buildings

Paint the grass around the buildings with the no. 8 sable flat and White + Cadmium Yellow Medium + a touch of Cobalt Turquoise + a touch of Indanthrone Blue. Go darker on the shaded side of both barns by adding more Indanthrone Blue. Paint with short, patting, downward strokes.

16 Add Pasture on the Right

Using the no. 6 bristle flat, paint the pasture on the far right with Indanthrone Blue + Cadmium Yellow Medium + White. Go darker as you move to the foreground by adding more Indanthrone Blue to the mix.

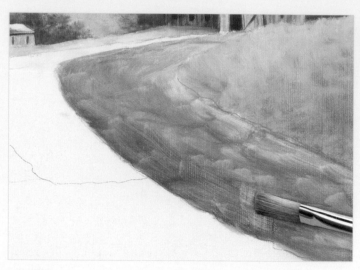

17 Begin the Cultivated Brown Field

Using the same brush, paint the brown field with White + Burnt Sienna + a touch of Naples Yellow. Vary the colors to give the dirt a streaky look. Shade the field with the dirty brush + a bit of Indanthrone Blue.

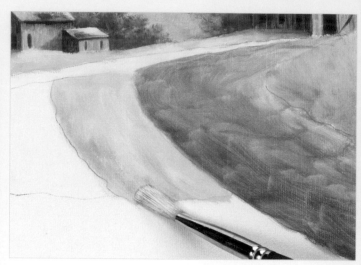

18 Begin the Cultivated Green Field

With the same brush, paint the green field to the left of the brown field with White + Cadmium Yellow Medium + a touch of Indanthrone Blue. Add touches of Burnt Sienna + White.

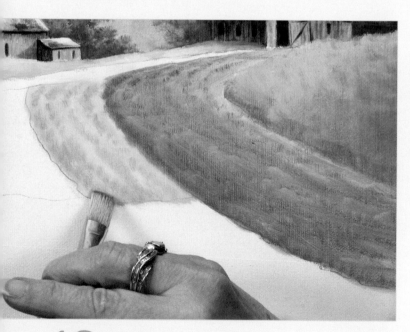

19 Pull in Crops on Both Fields

Add crops to the fields with slight downward pulls of the corner of the no. 6 bristle flat. Load very lightly. Use Indanthrone Blue + the tiniest bit of Cadmium Yellow Medium in the brown field. Use more yellow in the mix plus a bit of White in the green field. Curve the rows a bit to conform to the shape of the fields.

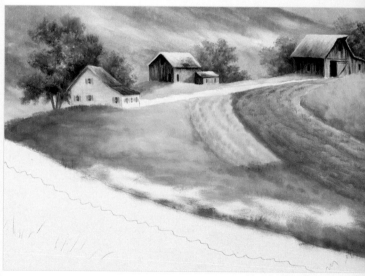

20 Paint the Grass in Front of House

With the same brush and Cadmium Yellow Medium + White + Indanthrone Blue, paint the grass in front of the house. Vary the color, placing the darker values with more Indanthrone Blue to the left. Leave unpainted canvas toward the bottom for the grassless dirt patches.

21 Paint Dirt Patches

Using the same brush with White + Burnt Sienna, paint the dirt patches, blending the edges into the grass. Also pat some of the greens (Indanthrone Blue + Cadmium Yellow Light) into the dirt.

22 Add the Dirt Road

Using the same brush, paint the road with White + Burnt Sienna. Mix the paint with more white as the road runs into the distance around the house and toward the large barn. Darken the color as the road runs into the foreground, picking up some Burnt Umber at the very bottom. Pat some grass color (Indanthrone Blue + Cadmium Yellow Medium) into the sides of the road.

23 Paint the Left-Corner Grass

Use the fan brush grass technique (see page 17) to paint the lower left corner with Indanthrone Blue + Cadmium Yellow Medium + White and a no. 4 bristle fan. As you paint, go darker toward the left corner and along the bottom. In the darkest areas, work a bit of Burnt Umber into the mix.

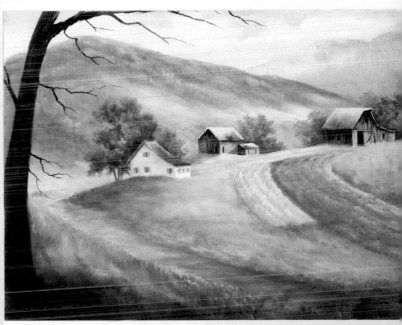

24 Paint Large Trunk and Branches

Using the no. 8 sable flat, paint the large trunk in the foreground with Indanthrone Blue + Burnt Umber, thinned with a bit of Liquiglaze. The larger limbs can be painted with the flat, but switch to a no. 1 sable liner for the smaller branches.

25 Add Leaves

Using the no. 8 sable flat and Indanthrone Blue + Burnt Umber, pat in leaves with strokes going in all different directions. Occasionally work in a bit of Cadmium Yellow Medium. Make the leaves "connect" or touch each other, so you don't end up with disconnected dots. More small branches can be added, if desired.

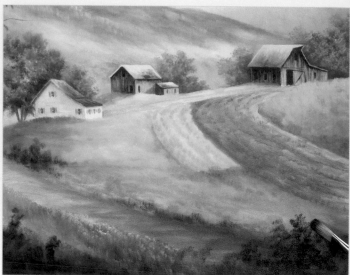

26 Paint Bushy Foreground Foliage

Working with the corner of the no. 6 bristle flat and Indanthrone Blue + Burnt Umber, add the dark bushy foliage at the bottom and to the right of the road, just before the curve.

27 Tap in Flowers

Tap in the flowers along the road with Ultramarine Violet + White loaded on the corner of the no. 6 bristle flat.

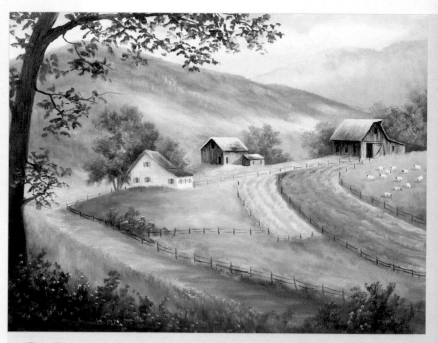

28 Add Fences and Sheep

Paint the fences with a no. 1 sable liner and thinned Burnt Umber + Indanthrone Blue. Space the posts further apart in the foreground to allow for perspective, and gauge the height of the back fence in proportion to the buildings.

Still using the no. 1 sable liner, paint the sheep in the pasture with White bodies and Burnt Umber heads. Use thinned Indanthrone Blue for the shadows.

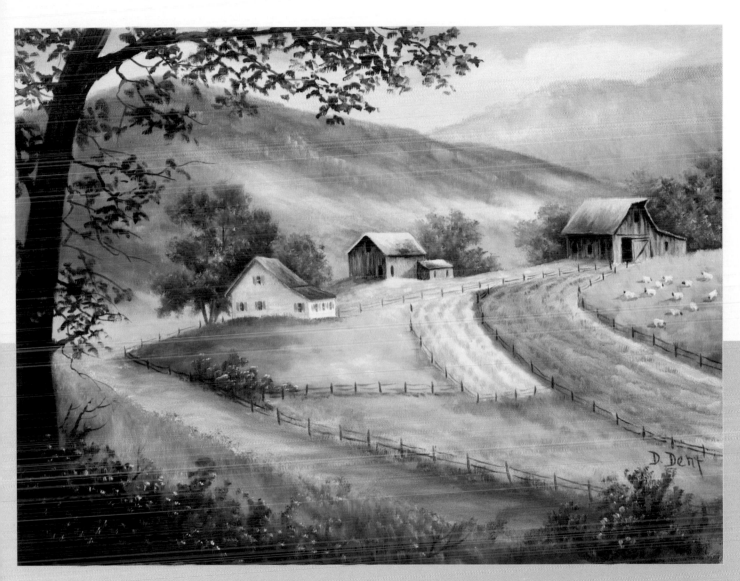

Take Another Look

Look at the painting in the last step to the left. The blue background hill creates good depth, and the green hill has some nice color changes. I like the misty look created by the turquoise blue and white behind the buildings.

The changes I want to make are mostly a matter of adding details. The tree in the foreground could use a few more branches and some weedy grasses at its base. Grass blades flipped up over the left side of the road would also be good. Finally, I feel that the ground beneath the sunny side of the house should be darker to bring out the brightness on the siding. These adjustments have been made to the painting above.

THE ROAD HOME

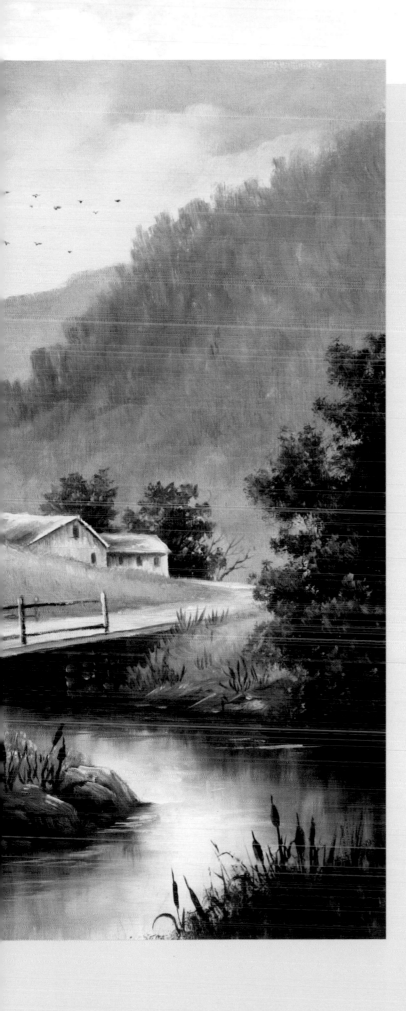

the road home

light from the left in autumn

Autumn has come to the landscape and summer's greens have given way to rich golds. The light from the left highlights the tops of the hills and the leaf clusters.

When you paint trees with lots of foliage, as you see here, don't think in terms of individual leaves. Think of groups or clusters of foliage, because that's what your eye sees. Think also about how the light sets up the clusters. Because the light hits the trees from the left, the individual foliage clusters are lighter on the left, fading down into shadow where the light doesn't strike. This play of light and dark gives the trees shape. If you lose too much of the dark, the light takes over and the trees look flat. You must have dark to have light.

| Burnt Umber | Cadmium Orange | Cadmium Red Light | Indanthrone Blue |

| Venetian Red | Yellow Ochre |

All paints are Martin/F. Weber Professional Permelba Artists Oil Color

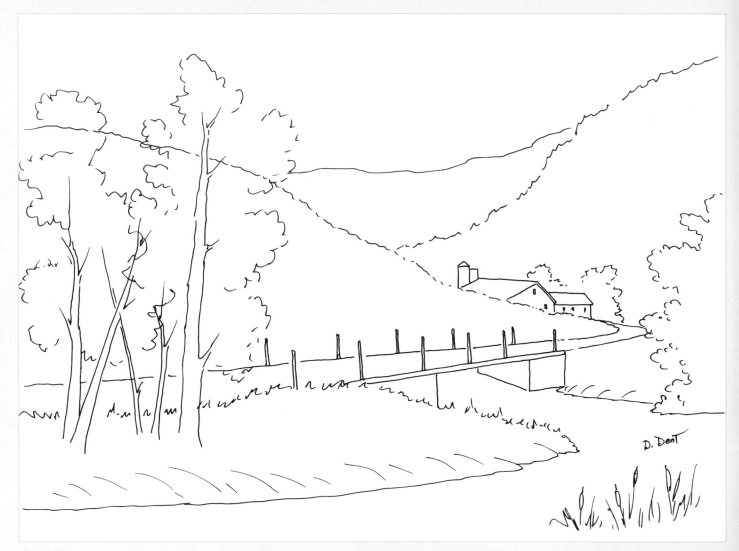

D. Dent

PATTERN

This pattern may be hand-traced or photocopied for personal use only.
Enlarge at 200 percent. Enlarge again at 107 percent to bring up to full size.

Naples Yellow	Raw Sienna	White	Ultramarine Violet

materials

Surface

Stretched canvas, 12" x 16" (31cm x 41cm)

Dorothy Dent Brushes

- Small background (no. 6 bristle flat)
- Detail flat (no. 8 sable flat)
- Foliage fan (no. 4 bristle fan)
- Liner (no. 1 sable liner)
- Filbert (no. 4 sable filbert)

Other Materials

- White gesso
- 2-inch (51mm) disposable sponge brush
- Tracing paper
- Black graphite paper, tape and stylus, pen or pencil
- Odorless turpentine (for rinsing and cleaning brushes) and rinse basin
- Palette
- Martin/F. Weber Liquiglaze
- Martin/F. Weber Res-n-gel
- Paper towels
- Damar Varnish

a quick look at lighting and values

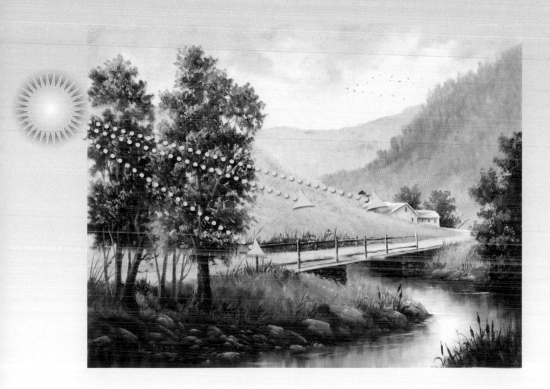

SEASON
Autumn

TIME OF DAY
Afternoon

LIGHT SOURCE
Sun on the left

This black-and-white photo of "The Road Home" allows you to see the relative dark and light values in the painting without the distraction of color.

As the diagram indicates, the light comes from the sun to the left of the painting.

1 Prepare for Painting and Paint Sky

If the canvas is rough, add one or two coats of white gesso. Trace the pattern onto the canvas with black graphite paper. (See pages 8-9.) As you paint with oils, add a bit of Liquiglaze to your colors to help them spread easily. Add a little Res-n-gel to the entire pile of White so it will dry faster.

Using the no. 6 bristle flat, paint the upper sky with White + Indanthrone Blue, leaving the bottom edge somewhat jagged. Paint the lower sky White + Naples Yellow, starting toward the bottom and working up to meet and blend with the blue.

2 Paint Distant Hill with Hint of Trees

Using the same brush, paint the distant hill Indanthrone Blue + White + a touch of Cadmium Red Light. Go lighter toward the bottom. Pat in some Venetian Red + White for a hint of trees.

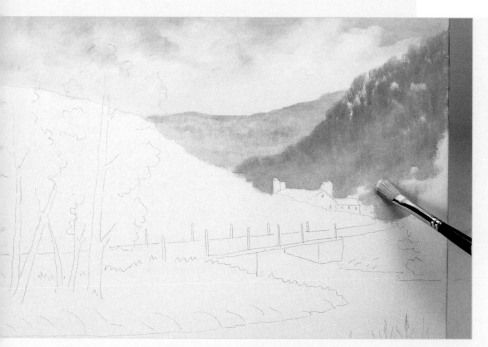

3 Paint Hill on Right

Using the same brush, base the hill on the right with downward choppy strokes. The texture should suggest trees. Use Indanthrone Blue + White + Cadmium Red Light as you did for the middle hill, but in a darker value (less White). Leave some white canvas showing. Changing to a no. 8 sable flat, paint a hazy blue area of White + Indanthrone Blue + a touch of Ultramarine Violet, blending into the hill color.

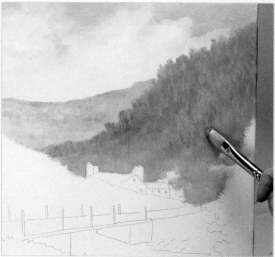

4 Add Autumn Foliage

Going back to the no. 6 bristle flat, add autumn foliage on the hill with Venetian Red + White, sometimes working in a touch of Naples Yellow. Hold the brush almost perpendicular to the painting surface and make short downward strokes.

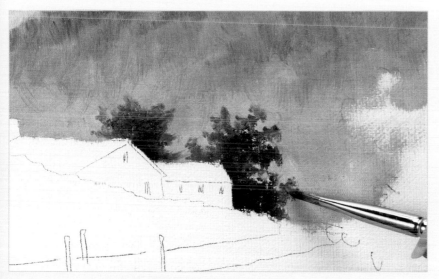

5 Pat in Trees Behind Barn

Using the no. 8 sable flat, pat in the trees behind the barn with Venetian Red + Indanthrone Blue + a touch of White.

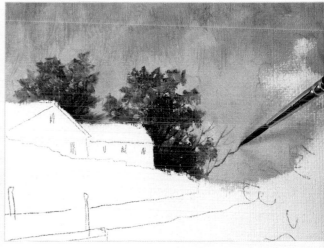

6 Add Highlights, Trunks and Limbs

Using the same brush, pat in highlights of Naples Yellow and Naples Yellow + Cadmium Orange. Using a no. 1 sable liner, add trunk and limb lines with Indanthrone Blue + Cadmium Red Light.

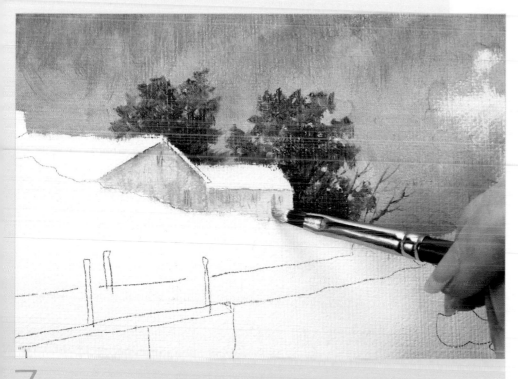

7 Base Barn Walls

Using a no. 4 sable filbert, fill in the sides of the barn with a light value of White + Raw Sienna.

TIP

Always begin the light foliage beyond the dark basecoat. The dark basecoat belongs inside the tree for dark shadows, but the light leaves extend further out.

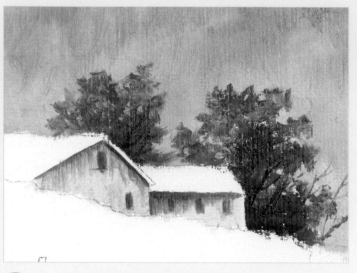

8 Shade and Add Windows

Lay Burnt Umber under the roof edges and on the left of the shed extension. Pull the color down a bit. Add Burnt Umber windows.

9 Base and Shade Silos

Still using the no. 4 sable filbert, paint the silos with Burnt Umber on the left and Raw Sienna + White on the right, blending in the middle. The left silo's cap is Burnt Umber.

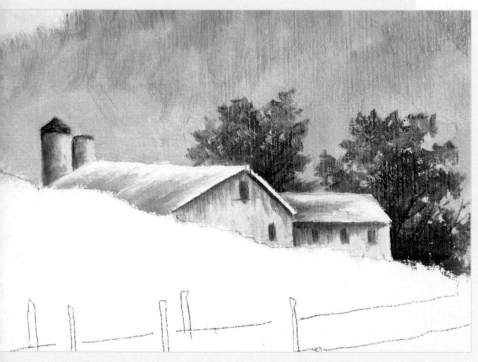

10 Paint Roofs

Using the same brush, paint the barn roofs with a rusty color of Venetian Red + Burnt Umber + White, stroking upward. Add White from the top, loosely blending into the rust.

11 Stroke in Grass on the Hill

Using a no. 4 bristle fan, use the fan brush grass technique (see page 17) to stroke in grass on the larger hill to the left with Naples Yellow + White, adding touches of Venetian Red to the mix here and there. Be sure you have good contrast between the barn and the hill. Toward the bottom of the hill, add hints of green with Indanthrone Blue + Naples Yellow + White. Add spots of grass color where the trees on the left will be.

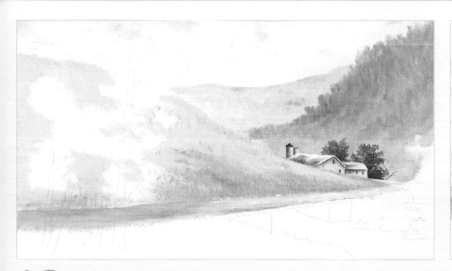

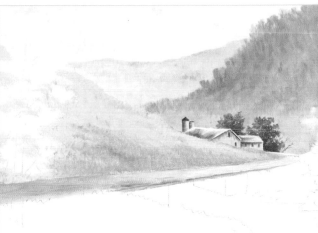

12 Base the Road

Using the no. 8 sable flat, base in the road with White + a touch of Venetian Red, adding more white as the road approaches the barn.

13 Shade the Road and Define Bridge Edge

Add touches of Indanthrone Blue + White in the nearer areas of the road. Show the thickness of the bridge with Indanthrone Blue + Venetian Red + a touch of White. With the chisel edge of the brush, paint defining lines at the top and bottom of the bridge edge with darker Indanthrone Blue + Venetian Red.

14 Base the Water

Using the no. 6 bristle flat, paint the dark water beneath the banks with Indanthrone Blue + Burnt Umber, pulling the strokes downward. Using a no. 8 sable flat, also paint the water on the far side of the bridge and between the trees, going lighter as you move further from the bridge. Be sure to maintain a line between the bridge and the water.

15 Begin Water Highlights

Starting at the edge of the dark water against the banks, stroke in White + Indanthrone Blue + occasional touches of Ultramarine Violet, using the no. 6 bristle flat. Leave some white canvas in the middle of the foreground water.

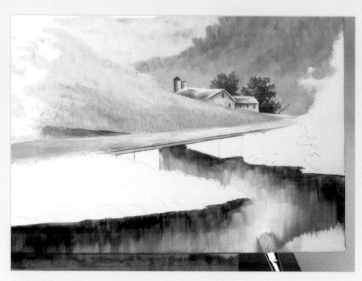

16 Add Brightest Water Highlight

Using the same brush, add the shine area of the water with downward strokes of White + a touch of Naples Yellow.

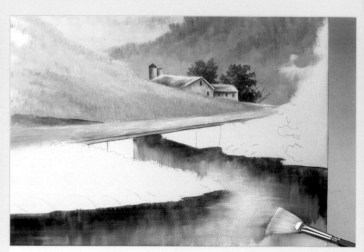

17 Distort Water

With the no. 4 bristle fan, distort the water with ever-so-light horizontal strokes. If you lose too much of the shine, stroke it back in with downward strokes. Then repeat the distortion lines. Continue in this manner until you get the effect you like..

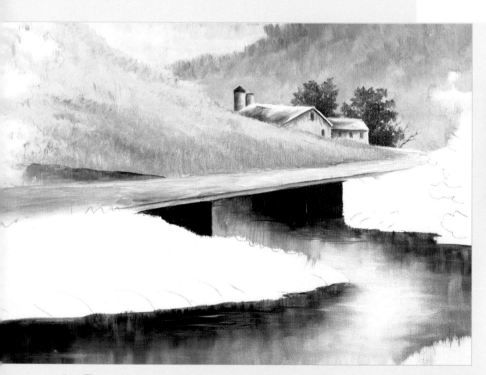

18 Base Bridge Supports

Using the no. 8 sable flat and Indanthrone Blue + Burnt Umber, paint the bridge supports. Pull some of the color into the water and then distort it with back-and-forth chisel-edge strokes to create a reflection.

19 Define Support Stones

Using the no. 4 sable filbert and White + Venetian Red, paint the stones on the fronts of the bridge supports. Leave some dark background mortar lines. If you want, you can barely suggest a few stones on the support sides, but let the distinct stones in front establish the corner of the bridge support.

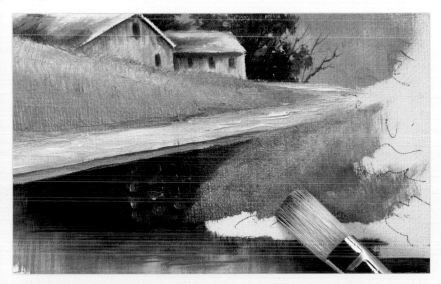

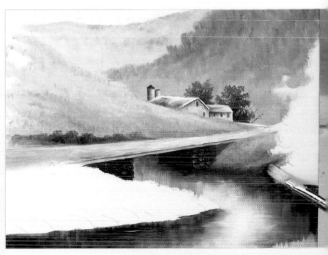

20 Paint Grassy Bank on the Right

Using a no. 6 bristle flat, paint the grassy bank to the right of the road, leaving a little area at the bottom for a dirt bank. Use Naples Yellow + White, adding a bit of Indanthrone Blue and occasional Venetian Red for the darker area.

21 Base Dirt Bank and Far Bank

Using the same brush, base in the dirt bank with Venetian Red + a touch of Indanthrone Blue + a bit of White. Also base in the dark bank area on the far side on the bridge.

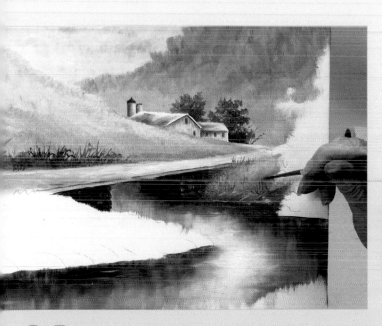

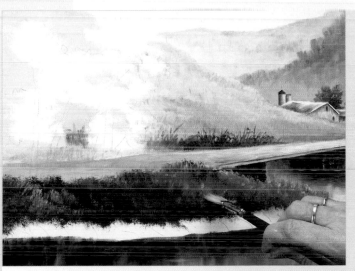

22 Highlight Dirt Bank and Flick in Grasses

Highlight the dirt bank in front of the right post with White + a touch of Venetian Red. Then use a no. 1 sable liner to flick up tall weeds of Burnt Umber + Indanthrone Blue on the bank beyond the bridge. Let some of the weeds curve and bend. Also flick in some grasses in front of the right post and on the dirt bank.

23 Base Grassy Bank on the Left

Using a no. 4 bristle fan to implement the fan brush grass technique (see page 17), base the grassy bank in the foreground with Raw Sienna + White. Add in Venetian Red and Indanthrone Blue to vary the color. Note that the colors darken as they move to the left edge of the painting.

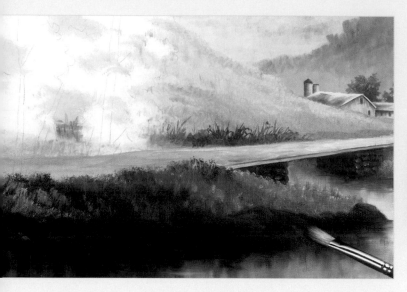

24 Base the Rocks

Using the no. 6 bristle flat, base in the rocks along the bank with Burnt Umber + a touch of Indanthrone Blue and a touch of Venetian Red. Let the rocks rise into the grass. Pull some of the rock color down into the water to create reflections.

25 Shape and Define Rocks with Highlighting

Highlight the rocks with White + Burnt Umber. For lighter highlights, use White + Raw Sienna. For the larger rocks, stroke in the top of the rock, change the angle of the brush, and pull down to suggest the side, using less paint. Giving the rocks lighter tops and slightly darker sides shapes them. Be careful not to lose all the dark base. You also need separation areas between the individual rocks, so remember to work light against dark.

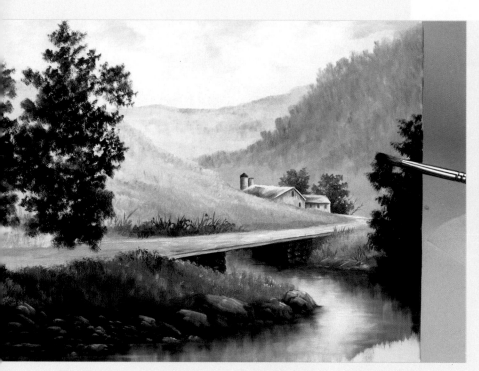

26 Base Riverbank Tree Foliage

Using the no. 6 bristle flat, base in the tree foliage on both sides of the river with a dark value of Venetian Red + Indanthrone Blue.

27 Highlight Left-Bank Foliage and Add Trunks and Limbs

Add light leaves on the left trees with Naples Yellow and Naples Yellow + Venetian Red, using the bottom corner of the no. 8 sable flat. Work for groupings or clusters of foliage with the lighter leaves to the left of the leaf groups. Add trunks and a few limbs with the no. 1 sable liner and thinned Burnt Umber + Indanthrone Blue.

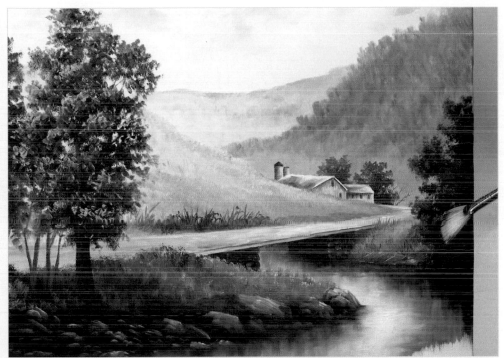

TIP

The trees on the left are rather close in the foreground, so the leaves should appear more distinct than those of the trees on the right. This is accomplished by highlighting with the sable flat. Using the bristle fan for highlighting gives a more blurred look for more distant tree foliage.

28 Highlight Right-Bank Foliage

With a no. 4 bristle fan, highlight the foliage of the trees on the right, using the fan brush foliage technique. Use Naples Yellow and Venetian Red, tapping in more Naples Yellow to the left of the clusters.

30 Base and Highlight Fence

Using the no. 4 sable filbert or the no. 1 liner, paint the fence on the bridge with Burnt Umber + Indanthrone Blue. Highlight the left side of the posts with White.

29 Highlight Trunks and Branches

Using the no. 1 sable liner, highlight the trunks and branches of the tree on the left with Naples Yellow, adding in a bit of White here and there.

139

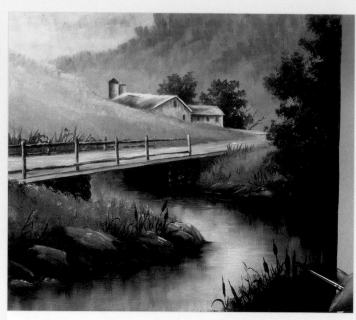

31 Base Grass in Right Corner

With a no. 4 bristle fan, use the fan brush foliage technique to base the lower right corner with Indanthrone Blue + Burnt Umber. Occasionally add a touch of Raw Sienna or Venetian Red.

32 Add Cattails and Grassy Weeds to Banks

Using the no. 1 sable liner and thinned Indanthrone Blue + Burnt Umber, paint cattails and weeds on both banks. For the cattails, first stroke in the stem, and then, a bit below the top, thicken the stem to form the cattail. On the left bank, also add a few weeds in Yellow Ochre + Raw Sienna, using the no. 1 liner.

33 Stroke in Ripples

Add ripple lines near the left bank with a no. 8 sable flat and White. These are just small horizontal or zig-zag strokes.

34 Paint Geese

Add geese flying in a loose "V" formation with a no. 1 sable liner and Indanthrone Blue + Burnt Umber + White. Use very little paint so they will look distant.

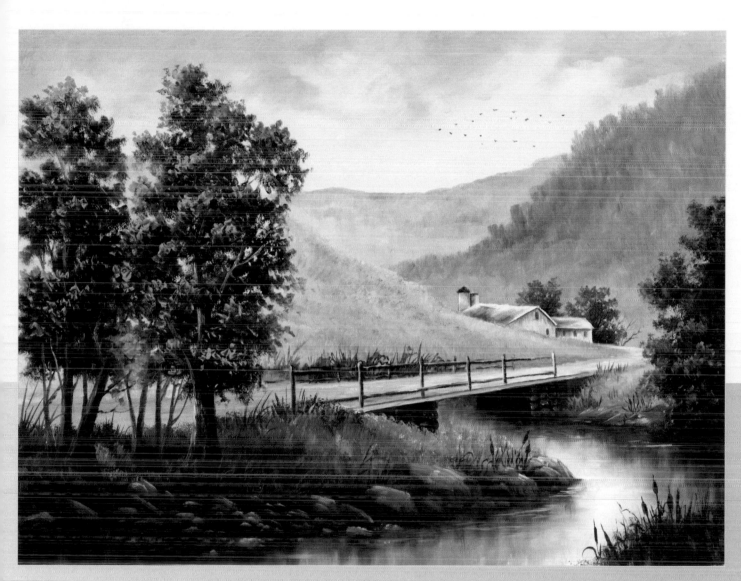

Take a Closer Look

Look at the painting in the last step to the left. The first thing I notice is that I put the shadow on the wrong side of the large silo. Whoops—even experienced painters make mistakes! If the painting is dry, you can just repaint. If the paint is wet, you can remove the color with a wipe-out tool or with a brush dampened with brush cleaner.

I like the light coming across the hill, hitting the edge of the trees, setting off the house and lighting the shine on the water. The two more distant mountains have great texture, suggesting trees, with the mountain in the back appropriately less distinct. I like that effect.

The nearer gold hill has a smooth area in the mid area, which could use a more grassy texture. I also feel the weed colors on the far side of the road (see step 33) could be more varied. These adjustments plus the silo shadow correction have been made to the painting above.

resources

Paints, Brushes and More

DecoArt
P.O. Box 386
Stanford, KY 40484
Phone: 800.367.3047
www.decoart.com

Dorothy Dent
Painter's Corner Studio
108 West Highway 174
Republic, MO 65738
Phone: 417.732.2076
www.ddent.com

J.W. etc. Quality Products
11972 Hertz Street
Moorpark, CA 93021
Phone: 805.529.9500
www.jwetc.com

Martin/F. Weber Co.
USA and International,
except Canada
2727 Southampton Road
Philadelphia, PA 19154-1293, USA
Phone: 215.677.5600
www.weberart.com

Canada
26 Beaupre
Mercier, Quebec J6R 2J2, Canada
Phone: 866.484.4411

Canadian Retailers

Crafts Canada
107 May Street South
Thunder Bay, ON P7C 3X8
Tel: 888.482.5978
www.craftscanada.ca

Folk Art Enterprises
73 Marsh Street
Ridgetown, ON, N0P 2C0
Tel: 800.265.9434
www.folkartenterprises.net

MacPherson Arts & Crafts
91 Queen Street East
P.O. Box 1810
St. Mary's, ON, N4X 1C2
Tel: 800.238.6663
www.macphersoncrafts.com

Maureen McNaughton
Enterprises Inc.
Rural Route #2
Belwood, ON, N0B 1J0
Tel: 519.843.5648
www.maureenmcnaughton.com

Mercury Art & Craft
Supershop
332 Wellington Street
London, ON, N6C 4P6
Tel: 519.434.1636

Town & Country Folk Art
Supplies
93 Green Lane
Thornhill, ON, L3T 6K6
Tel: 905.882.0199

U.K. Retailers

Art Express
1 Fairleigh Place
London N16 75X
Tel: 0870 241 1849
www.artexpress.co.uk

Atlantis Art Materials
7-9 Plumber's Row
London E1 IEQ
Tel: 020 7377 8855
www.atlantisart.co.uk

Crafts World (head office)
No. 8 North Street, Guildford
Surrey GU1 4AF
Tel: 07000 757070

Green & Stone
259 Kings Road
London SW3 5EL
Tel: 020 7352 0837
www.greenandstone.com

Hobby Crafts (head office)
River Court
Southern Sector
Bournemouth International Airport
Christchurch
Dorset BH23 6SE
Tel: 0800 272387

Homecrafts Direct
P.O. Box 38
Leicester LE1 9BU
Tel: (+44)116 2697733
www.homecrafts.co.uk

index

the best in painting instruction and inspiration is from North Light Books!

Painter's Quick Reference: Trees & Foliage

A great book of both instruction and inspiration in one go-to reference! With 40 step-by-step lessons from favorite decorative painters and landscape artists, this book covers a variety of evergreens, shrubs, leaves, deciduous trees, grasses and distant foliage. There are no difficult techniques to master, no boring theory and no heavy-duty instruction. Just pure, put-it-to-work directions with lots of pictures and short, clear captions.
ISBN 1-58180-613-2, paperback, 128 pages, #33183

Folk Art Landscapes for Every Season

Fill your home with the timeless charm of folk art scenes! Popular instructors Judy Diephouse and Lynn Deptula team up to show you how to capture the quaint and picturesque beauty of rolling farmland, old-fashioned barns, rural churches and country gardens. You'll find ten projects for adorning wooden boxes, picnic baskets and more. Easy-to-trace patterns, paint color charts and start-to-finish instructions make each project a joy to create.
ISBN 1-58180-117-3, paperback, 128 pages, #31813

Painting with Brenda Harris Volume 1: Cherished Moments

Beloved TV painter Brenda Harris brings all the charm and approachability of her PBS show to this delightful book. It's an insightful guide for both decorative painters and fine artists, with templates, instruction on basic painting materials and techniques, and 13 step-by-step acrylic projects anyone can paint. It's fast and fun to paint beautiful, heartwarming acrylic scenes with Brenda Harris' proven teaching methods.
ISBN 1-58180-659-0, paperback, 112 pages, #33254

Land & Light Workshop: Capturing the Seasons in Oils

All artists can capture the stunning beauty of the seasons in oils with Tim Deibler at their side. Deibler shows you how to understand light and truly see your subjects in step-by-step lessons that include shape, value, color and edges; five practical, hands-on strategies for starting any painting; and side-by-side comparisons of the same scene painted in all four seasons. Whether you're a beginning or advanced oil painter, this book will help you make your oil landscapes more captivating!
ISBN 0-58180-476-8, hardcover, 128 pages, #32744

These books and other fine North Light titles are available at your local arts & craft retailer and bookstore and from online suppliers.